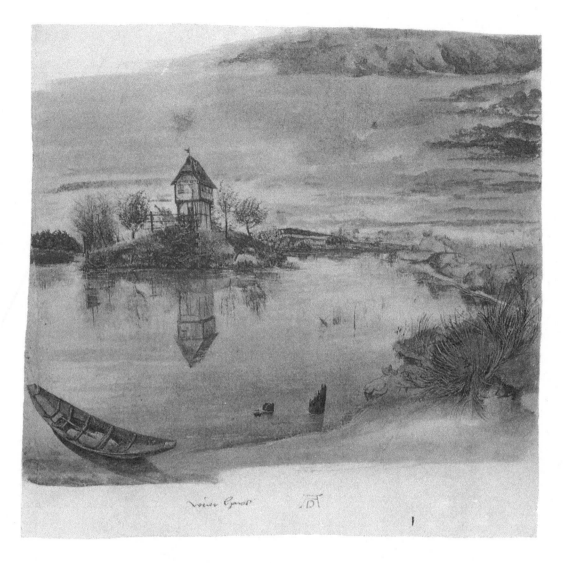

THE "WEIHERHÄUSCHEN."
Watercolor and opaque colors. British Museum, London.
213 × 222 mm; $8\frac{3}{8}$ × $8\frac{3}{4}$ in.

The picture shows a section of river landscape at sunset on a stormy day. The river is the Pegnitz; the building is the "Weiherhäuschen" (pond hut) situated on an island in the river not far from Nuremberg. The legend reads: "weier Haws." Since this motif was used in the background of the engraving "The Madonna with the Monkey," this drawing can be approximately dated 1500.

DRAWINGS OF
Albrecht Dürer

Selected and with an Introductory Essay by

H E I N R I C H W Ö L F F L I N

———

translated by Stanley Appelbaum

with a new Foreword by Alfred Werner

DOVER PUBLICATIONS, INC.
MINEOLA, NEW YORK

This Dover edition, first published in 1970, is a new translation
of the tenth edition (1923) of *Albrecht Dürer, Handzeichnungen*,
first published by R. Piper & Co., Munich, in 1914. A new Fore-
word has been written specially for the present edition by Alfred
Werner. The Bibliographical Note provides further information
on the specific features of this edition.

Library of Congress Catalog Card Number: 70–111607

International Standard Book Number

ISBN-13: 978-0-486-22352-0
ISBN-10: 0-486-22352-3

Manufactured in the United States by LSC Communications
22352320 2017
www.doverpublications.com

FOREWORD

Over the main entrance to New York's Metropolitan Museum of Art are portrait medallions commemorating six supreme geniuses in the field of fine art. These great men—Bramante, Dürer, Michelangelo, Raphael, Rembrandt, and Velázquez—were honored in the last years of the nineteenth century, but if a committee of art scholars reviewed the selection today, it is likely that they would concur in the choice of Albrecht Dürer (1471–1528) as one of the world's half-dozen greatest artists. Because of his individualism (he would qualify as a great man by Emerson's definition of one "who is what he is from nature, and who never reminds us of others"), subjectivism and insatiable thirst for knowledge, he appeals to our own age of creative turmoil more strongly than does any other artist who had reached manhood by the end of the fifteenth century.

Dürer, unquestionably the major figure of the Northern Renaissance, is unique among his contemporary compatriots because he alone had nothing retrogressive and provincial about him; he alone came close to the ideal of a European artist and found admirers far beyond the German lands. This is how Erasmus of Rotterdam eulogized him:

What does he not express in monochromes, that is, in black lines? Light, shade, splendor, eminences, depressions; and, though derived from the position of one single thing, more than one aspect offers itself to the eye of the beholder. He observes accurately proportions and harmonies. Nay, he even depicts that which cannot be depicted . . . the whole mind of man as it reflects itself in the behavior of the body, and almost the voice itself. These things he places before the eye in the most pertinent lines—black lines, yet so that if you should spread on pigments you would injure the work

While one may hesitate to call Dürer a "modern" man, one can readily agree with Erwin Panofsky that he was the first German to be self-consciously an artist. Unwilling to content himself with the traditional role of "an honest craftsman who produces pictures as a tailor makes coats and suits," he raised himself from the status of a humble medieval artisan to

that of a patrician, on an equal footing with persons of erudition, wealth and power. Held in high esteem not only by Erasmus, but also by other influential men, including some exacting Italian masters, Dürer accepted all admiration with gracious poise. Alone among the Northern artists of his time, he drew and painted his own features repeatedly, and he did so without a trace of humility. In fact, his self-portrait of 1500 (now in the Alte Pinakothek in Munich) led one biographer (Michael Levey) to say: "Dürer is here the Redeemer, and he has modified his own sharp-featured reality to conform to the traditional type of Christ."

Dürer is also unique in that he treasured his own sketches, and cared to sign many of them with his famous monogram and date even though they were not intended for sale, but generally as gifts for close friends. Approximately one thousand of his sketches have survived, whereas only thirty-odd drawings by Matthias Grünewald have come down to us. Of course Grünewald, as Mathis Gothart Neithardt is still being called although his proper name was long ago rediscovered, was essentially a painter, whereas his coeval Dürer was primarily a graphic artist—indubitably the greatest draftsman of his time, and among the most accomplished draftsmen that ever lived.

The Swiss-born art historian Heinrich Wölfflin (1864–1945) was, of course, aware of all Dürer's great talents and unique characteristics; perhaps all too aware of the fact that among German-speaking people there had developed an idolatry of the master from Franconia that resisted critical analysis. In his first book-length study, *Die Kunst Albrecht Dürers* (1905), Wölfflin limited the purely biographical information to a few lines, and concentrated instead on an exposition of the "how" and "why" of the master's art. The exciting story of the goldsmith's son who became a protégé of Emperor Maximilian I and the pride of the Free Imperial City of Nuremberg had long become part of *Allgemeinbildung* (general education) in Central Europe; there was a plethora of literature about him, ranging from the serious pioneer work by Moritz Thausing down to popular, partly fictionalized, biographies that were exaggerated in their adulation and that verged on the ridiculous.

As if to counteract the bad effects of such sentimental and often flowery prose, Wölfflin rigidly avoided superlatives and employed an austere style bordering on a mathematician's coolness whenever he wrote on the master—in the aforementioned book of 1905; in his foreword to an

edition of Dürer's literary remains (1908); in the introduction and explanatory notes to *Albrecht Dürer, Handzeichnungen* (first issued in 1914); in his two public lectures on Dürer (the first delivered in 1921 to a national convocation of students at the University of Erlangen, the second in 1928, in Nuremberg, at the quadricentennial commemoration of the artist's death); and in sundry brief treatises in scholarly yearbooks and learned journals. In the same dry "cool" manner are his numerous references to Dürer in his pivotal work, *Kunstgeschichtliche Grundbegriffe* (1915; translated into English as *Principles of Art History*), and especially in *Italien und das deutsche Formgefühl* (1931; translated into English as *The Sense of Form*).

But it would be wrong to assume that Wölfflin's severe style—the very opposite, say, of Walter Pater's—is due to a lack of enthusiasm for his subject. On the contrary, it was only through direct contact with works of art (at least with those with which he could empathize, since he had many blind spots) that he, the reticent bachelor, the shy recluse, came to life. Some who were privileged to sit at his feet at the universities of Basel, Berlin, Munich, or, finally, Zurich have recorded the deep impression he left upon them. E. H. Gombrich, director of the Warburg Institute in the University of London, recalled that Wölfflin held the audience in the largest lecture hall of Berlin spellbound. Another scholar, the late Wolfgang Born, has written about this inspiring pedagogue:

The task of interpreting art to his students was a challenge to ever more concise formulations. It was the most exciting intellectual spectacle I have ever experienced. In the darkened room, the tall figure of the professor appeared as a black silhouette. He stood next to the slide machine in the back of his auditorium, very calm, his unforgettable head—the child of one of his friends called it a lion's head—slightly raised. Haltingly and tersely the words came from his mouth, stimulated by the picture which appeared on the screen and elucidating its significance with uncanny accuracy. How splendidly selected were his examples! Most of them contrasting types. The way in which he compared them was a revelation to all of us. Each lecture was a new adventure in "seeing."

This is exactly what Wölfflin wanted to teach: how to look at a work of art. Unlike Pater, he had no facility with words, and he did not really consider himself a writer. And unlike Panofsky, whose *Albrecht Dürer* (first published in 1943, revised in 1945) is the work to be most heartily

FOREWORD

recommended to the American reader for further study, he had little interest in the intellectual, philosophical, and religious currents of Dürer's age. What interested him was exclusively this: why Dürer preferred certain solutions to formal problems, and how he achieved his desired aesthetic goals.

Frustrated in expressing his own artistic inclinations as he is known to have been, Wölfflin sought to put himself in the artist's place in order to reconstruct the creative act. From works completed centuries before his own time he had divined Dürer's method of seeing and of translating his inner vision into lines and colors. He tried to establish the probable reasons for Dürer's choice of one medium instead of another, or of one structural solution in preference to other possibilities. He went still further and treated Dürer not as an unassailable "Old Master" but as an unproven artist whose work should be judged by critical standards and compared to determine why certain items were more or less successful than others. As he explained in an early work, *Klassische Kunst* (1899; translated into English as *Classic Art*), he aimed to teach art lovers about "those things which constitute the value and the essence of a work of art," rather than to give them "mere biographical anecdotes or a description of the circumstances of the time."

All of this may appear self-evident today, but in 1888, when Wölfflin embarked upon his teaching career, art history was still a branch of *Kulturgeschichte*, not an independent *Fach*. He wanted to lay the foundations for a discipline that would serve art the way philology serves literature. By more or less disengaging the study of drawings, prints, paintings, sculptures, and buildings from non-artistic details, by focussing on form and style as the crux of artistic meaning, Wölfflin ushered in the concept of art history as a "history of artistic vision."

He did have a few predecessors. Long before him, Winckelmann had warned, "It is not enough to say that something is beautiful—one ought to know also to what degree and why it is beautiful." Goethe, in his old age, observed that while everyone could see the subject, form was invisible to most people. Wölfflin's immediate precursor, however, was Konrad Fiedler, who, in a slim but important volume, *Über die Beurteilung von Werken der bildenden Kunst* (1876; now accessible in English under the title *On Judging Works of Visual Art*), summed up in one sentence the feeling of these two predecessors, and also forecast Wölfflin's *Grundbegriffe:*

"The understanding of art can be grasped in no other way than in terms of art."

Wölfflin's edifice of thought is not easy to characterize in a sentence or two. But if a summation must be attempted, one might perhaps say that one basic idea runs like a red thread through his writings: that there is an evolution of artistic forms with its own laws and dialects, and that these inflexible laws are independent of social conditions and individual taste.

To be sure, Wölfflin formed his philosophy after having looked earnestly at thousands of works of art and architecture. Indeed, art scholars are grateful for his endeavors to give structure to what hitherto had been vague and unformulated, specifically for his concept of *Grundbegriffe*, that is, five pairs of concepts fundamental to the analysis of stylistic entities. Wölfflin hoped that these paired concepts would be of major importance as formal patterns of universal applicability, but he was finally compelled to admit the contradictions in, and the limitations of, his own method, which, to today's scholars, appears as something like a bed of Procrustes. Into this rigid frame he tried to fit Dürer by insisting that Dürer had developed a "pure linear style"—after all, the contrast between "linearism" (as characteristic of Italian art) and the "painterly" approach (as a rather Northern feature) plays a great role in his theory.

Critics can claim and have claimed that Wölfflin carefully selected for this book only the Dürer drawings that would prove his thesis: that Dürer and Raphael represented similar formal aims, and that Dürer, after so much exposure to Italian art, to his end remained enslaved by the High Renaissance. Indeed, it would be quite possible to make an entirely different selection from the large number of individual drawings by Dürer that have survived, and many an exception would challenge the professor's doctrinaire approach. There are, in fact, "painterly" modulations of tone in some of the pictures included in this anthology, which duplicates Wölfflin's selection.

However, it is only fair to state that a decade and a half after the initial publication of this work, in the last of his major books, *Italien und das deutsche Formgefühl*, Wölfflin modified the dichotomy he had created between the young German and Gothic Dürer, and the mature "Italian" and "Renaissance" Dürer. A few quotations from the 1931 work will demonstrate this more seasoned approach:

Dürer had never intended to sacrifice German art to Italian art; he took whatever he needed, without letting himself be driven from the native soil in which his imagination was rooted.

Dürer is properly considered a central figure in German art rather than a peripheral one, since many anti-Italianate tendencies coexisted in him with those sympathetic to Italian aims.

Wölfflin reached the conclusion that, all his "Italian" traits notwithstanding, Dürer was distinguished from the Southern artists by the strong internal movement of elements within a composition. With "The Great Piece of Turf," Plate 16A, obviously in mind, he writes:

Despite all his clarity in the representation of a leafy plant, a German artist can always be recognized by his perception of a secret life that goes from leaf to leaf and entwines one leaf with the next.

At the same time, the scholar clings—quite legitimately—to his contention that Dürer, inspired by his intimate contacts with the art produced south of the Alps, introduced a fresh note into Central European art. "A new world was opened up to the North by these self-contained figures who, as independent and complete beings, are regulated by their own inner laws," he writes with reference to "Adam and Eve" (Plate 20). Instead of the interlocked forms found in Gothic church decorations, here are "free, self-reliant figures" that have their value in themselves and reveal themselves through their own form."

In other words, in the last analysis, Dürer, Germanic though he was and remained to the end, broadened his compatriots' outlook by introducing Southern clarity:

For Italy, art is a science Dürer accepted this concept of art. To him, to represent meant to know. He fought against a lax practice that, without theoretical basis and without real knowledge of the subject, was guided only by an obscure pictorial impulse. He calls this mere "Brauch" and opposes it to true art.

In a way, with slight changes, the sentence beginning "He fought against a lax practice . . ." can apply to the art historian Wölfflin, whose concentration on the strictly visible had an enormous influence on his pupils, many of whom were to occupy important positions as educators or directors of museums. He set a model for the future by his language, which

is sparing and precise, in contrast to so much writing on art characterized by poetic vagueness that opens the door to error and confusion. English readers will welcome the addition of another Wölfflin book to the four works already available to them. This convenient edition of Dürer's drawings will be of great interest on the eve of the five-hundreth anniversary of Dürer's birth, which will be celebrated, not only in Nuremberg, but wherever the impact of the German master's genius has been felt.

ALFRED WERNER

New York
September, 1969

BIBLIOGRAPHICAL NOTE

Albrecht Dürer, Handzeichnungen, by Heinrich Wölfflin, was first issued by R. Piper & Co. in Munich in 1914. It went through several editions, with minor changes in the text, the twelfth and last appearing during the war, in 1942. This, the first edition in English, is based on the tenth German edition of 1923.

The selection of drawings here is exactly that made by Wölfflin, which followed very conscious guidelines: the inclusion of works of primarily graphic interest, with a "historically proper" emphasis on the "developed, classic" type of Dürer's draftsmanship rather than on his earlier production; a chronological arrangement by and large, but with some groupings of technically related drawings within their stylistic periods.

The plate numbers in this English edition thus correspond to those of the tenth German edition, except that the present Plate 16A was formerly unnumbered and was reproduced in full color, as was the frontispiece. Wölfflin found the color work somewhat unsatisfactory, and these plates are now shown in black and white. All the drawings in this volume, in fact, have been reproduced from the larger and clearer illustrations in the four-volume Winkler catalogue mentioned below. This has also made it possible to include the entire sheet with three views of a helmet (Plate 18), whereas in the tenth German edition only the two top views were reproduced, to avoid drastic reduction of the drawing.

In the German edition Wölfflin expressed his regret that it was impossible to show the pictures in their natural size. Although the present format corresponds closely to the original book, the narrower margins allow the reproduction of most of the pictures at more nearly natural size.

BIBLIOGRAPHICAL NOTE

The tenth German edition lacked captions because Wölfflin believed that text on the same page with an illustration or even on a facing page, as in the present edition, detracted from the picture itself. His commentary was therefore in a separate section at the end of the book. Yet such information, discreetly printed, is of more use when presented alongside the illustrations, and so Wölfflin's notes and comments now accompany the individual drawings. These notes, in the author's words, "do not describe what any one can see, but attempt to give the reader certain viewpoints through a variety of observations. Anything approaching a full commentary was out of the question. Scholarly apparatus has also been omitted."

To the dimensions of drawings given in millimeters, the equivalents in inches have here been added. Information on ownership has been brought up to date on the basis of the data in the 1957 Winkler volume *Albrecht Dürer, Leben und Werk* (Berlin, Gebr. Mann Verlag), and the museums have been specifically named wherever Wölfflin supplied only the city in which they were located. For six pictures (Plates 6, 25, 29, 37, 68 and 70) the indication of ownership "Kunsthalle, Bremen" has been retained even though all these drawings disappeared at the end of the Second World War.

The List of Plates repeats some of the basic information from the captions, and also supplies the Lippmann (L) catalogue numbers as well as the more recent Winkler (W) catalogue numbers of the drawings. Plates 49 and 50 (from the Maximilian *Prayer Book*) and 52 (from the "Dresden Sketchbook") lack L and W numbers because neither catalogue includes drawings other than individual sheets. (The tenth German edition of Wölfflin had given all L numbers available at that time.)

Friedrich Lippmann was the director of the Print Division of Berlin's Kaiser Friedrich Museum, second only to the Albertina in Vienna in its collection of Dürer drawings. His monumental catalogue *Zeichnungen von A. Dürer in Nachbildungen* (the source of the L numbers) was begun in 1883; the fifth volume appeared in 1905, two years after Lippmann's death; the work was completed by Friedrich Winkler in two more volumes (1927 and 1929); the publisher was the G. Grote'sche Verlagsbuchhandlung in Berlin. Between 1936 and 1939 Winkler, by then himself serving in Lippmann's former capacity, published a new four-volume catalogue embodying new research (source of the W numbers), *Die Zeichnungen Albrecht Dürers* (Berlin, Deutscher Verein für Kunstwissenschaft).

The extremely brief and now outdated bibliography supplied by Wölfflin in the tenth German edition of this book has been omitted in the present edition. The Lange-Fuhse citations in the captions to Plates 59 and 60 refer to *Dürers Schriftlicher Nachlass* (Dürer's Literary Remains), edited by Lange and Fuhse, 1893.

A. W.

LIST OF PLATES

LIST OF PLATES

LIST OF PLATES

LIST OF PLATES

48 SEATED WOMAN, 1514
Pen. Kupferstichkabinett, Berlin. L.79; W.621.

49 PAGE OF MARGINAL DRAWINGS FOR EMPEROR MAXIMILIAN'S PRAYER BOOK, 1515
Pen with ink of different colors. Staatsbibliothek, Munich.

50 PAGE OF MARGINAL DRAWINGS FOR EMPEROR MAXIMILIAN'S PRAYER BOOK, 1515
Pen with ink of different colors. Staatsbibliothek, Munich.

51 DESIGN FOR A GOBLET, WITH A VARIANT OF THE BASE, MID 1510'S
Pen. British Museum, London. L.253; W.234.

52 SIX GOBLETS
Pen. Bibliothek, Dresden.

53 MALE AND FEMALE NUDES, 1516
Pen. Städelsches Kunstinstitut, Frankfurt. L.194; W.667.

54 MALE AND FEMALE NUDES, 1515
Pen. Städelsches Kunstinstitut, Frankfurt. L.195; W.666.

55 SEATED PROPHET, 1517
Pen. Albertina, Vienna. L.534; W.597.

56 ST. JEROME IN HIS STUDY [WITHOUT CARDINAL'S ROBES] CONTEMPLATING A SKULL
Pen. Kupferstichkabinett, Berlin. L.175; W.589.

57 THE MADONNA AND CHILD WITH A MUSIC-MAKING ANGEL, 1519
Pen. Windsor Castle. L.391; W.536.

58 A YOUNG GIRL OF COLOGNE AND DÜRER'S WIFE, 1520
Silverpoint. Albertina, Vienna. L.424; W.780.

59 CASPAR STURM, 1520
Silverpoint. Musée Condé, Chantilly. L.340; W.765.

60 THE CATHEDRAL OF AIX-LA-CHAPELLE WITH ITS SURROUNDINGS, SEEN FROM THE CORONATION HALL, October 1520.
Silverpoint. British Museum. London. L.404; W.763.

61 ANTWERP ["ANTORFF"], 1520
Pen. Albertina, Vienna. L.566; W.821.

62 PORTRAIT OF AN UNKNOWN MAN, 1520
Chalk. Kupferstichkabinett, Berlin. L.53; W.804.

63 "LUCAS VAN LEYDEN," 1521
Chalk and charcoal. British Museum, London. L.403; W.809.

64 PORTRAIT OF ULRICH VARNBÜHLER, 1522
Chalk and charcoal. Albertina, Vienna. L.578; W.908.

65 HEAD OF AN OLD MAN, 1521
Brush drawing with white highlights. Albertina, Vienna. L.568; W.788.

DÜRER'S DRAWINGS

The historical significance of Dürer as a draftsman lies in his construction of a purely linear style on the foundation of the modern three-dimensional representation of the real world. All drawing moves between the two poles of expression by line and expression by tone areas or masses. In the latter, of course, line need not be wholly absent, but it does not become important for its own sake. Rembrandt used the pen, too, yet the individual pen stroke is not present as a final end operative in its own right, but as an element incorporated into the impression made by the drawing as a whole. The viewer does not follow the course of the individual line, and cannot do so, because the line stops every moment, shifting his attention, or else becomes complicated to the point of inextricability: the masses are to convey the message, not the framework of lines itself. With Dürer it is just the opposite; the drawing is a crystal-clear configuration in which every stroke, rendered pure and perspicuous, not only has the function of defining forms, but possesses its own ornamental beauty. It is not enough to praise the power of Dürer's line and to ascertain that the expression is entirely entrusted to the interconnection of the major lines and the even flow of their directionality: there is, beyond this, the development of the stroke as an element in a decorative overall figure.

This style is not present at the outset. The fifteenth century did not yet possess it, and there are early drawings of Dürer which have a more "painterly" appearance than his later classic drawings. It is conceivable that modern sympathies may even lie more with those youthful works, but this does not alter the fact that it was the pure linear style that made Dürer's draftsmanship the cornerstone of sixteenth-century art.

There are no lines in nature. Any beginner can learn this if he sits down in front of his house with a pencil and tries to reduce what he sees to a series of lines. Everything opposes this task: the foliage on the trees, the waves in the water, the clouds in the sky. And if it seems that a roof clearly exposed against the sky, or a dark tree trunk, must surely be able to be

rendered in outline, even in these cases it is soon apparent that the line can only be an abstraction, because it is not lines that one sees, but masses, bright and dark masses that contrast with a background of a different color. After all, there are no black threads running along the edges of objects!

It is extremely strange that nevertheless it is possible to wrest an expression in line from the real world. Our eyes have become accustomed to linear abstraction; thanks to the efforts of generations, there is a language of line in which everything or at least practically everything can be said. And Dürer is one of the great discoverers; he extended the expressiveness of line in all directions and found the unsurpassable formula for rendering certain phenomena.

There are two senses in which we speak of lines in drawing: there are contour lines and there are modeling or shading lines.

There are contours in every drawing, but the greater or lesser accentuation of these contours makes a great difference. The more significance they have for the definition of form—that is, the more the figure approaches an objective silhouette—the greater significance the contours will have in comparison with the other lines. (By silhouette is meant not only the overall outline of a figure; inner forms also have their silhouette.) The significance of the contour line is further increased when it gains independence as a melodic voice. That is what happened in the sixteenth century. Now more, now less emphasized, the contour nevertheless is always a sure and clearly marked path. Beautiful in its own right, it contains the interpretation of the form.

Wherever this linear style turns toward the painterly, the contour quickly loses its importance. The eye is hindered in every way from using it as a path for observation. Finally all that is left, as resting places on the old road, is a few isolated line fragments or dots.

In its second application, line is used to achieve modeling. To be sure, line is not a self-evident means of representing light and shade, but the viewer raises no objection to seeing the dark area of a vaulted surface, or the part of a room that lies in shadow, transformed into a system of individual strokes. Here too the sixteenth century is the first century of decided linearity. Whereas previously longer or shorter strokes were placed side by side and one above the other to indicate the form of a mass, the technique becomes refined toward the close of the fifteenth century, and the classic linear artists make it their rule that the line systems of shaded areas be kept per-

fectly transparent and open, so that each individual stroke carries its own weight. Once again clarification of form and decorative beauty go hand in hand. The stroke that models is felt to be ornamental, but at the same time its movement is conditioned by the necessity for the course of the line to follow the given form. The line in a vaulted form is different from that in a flat form, an empty dark area in a room is not characterized in the same way as the shadow cast by a body. In fact, it is possible to communicate the qualities of textures by purely linear means, to express hardness and softness, the muscular firmness of a man's thigh and the gentle manner in which a woman's body yields to the touch.

Then, under the influence of painterly tendencies, the schema becomes confused. The individual line is lost in the overall mass. Alienated from form, it no longer retains any special ornamental significance, and only the large-scale rhythm of clusters and tone areas is left to tell the story. The drawing has forfeited its transparency, but in the same measure its power to differentiate textures has grown, and dark and light have acquired a mysterious life of their own.

Dürer used a great variety of media. There are pen drawings and brush drawings; he worked with charcoal and chalk; and alongside a lead-like metal point the older silverpoint is also to be found. The tools change according to time and occasion. For example, whereas the silverpoint became more and more Dürer's instrument during his travels and for quick sketching en route, it must be said that in his later years chalk had the same significance as the brush in his middle period. Throughout the years, however, the pen remains Dürer's favorite drawing tool: it is especially well adapted to satisfy the urge to give independent life to the individual strokes.

It is unusually stimulating to follow the course of the separate treatment of each technique in Dürer's work. Each time, when confronting nature, Dürer sets himself another problem, and the results achieved by a chalk drawing, for example, are basically different from those required of a pen drawing. Naturally, the final purpose of the drawing is the deciding factor. Studies for figures in a painting will not look like preliminary drawings for a woodcut. This is not to say, however, that the graphic style of the print has won a determining influence over the drawing; in fact, the opposite is the case: Dürer raised the woodcut to the level of pen drawing, *his* pen drawing.

[3]

Dürer's drawings should not be judged by naturalistic standards. They can never be viewed fairly if their fundamentally different intention is not understood: Dürer strives everywhere for a linear organism that is both decorative and independent, and the drawing consciously departs from natural appearances, sometimes more, sometimes less. There are flourishes and coloratura passages in this art, heightenings and sharpenings of the line that serve only to give the needy linear system a value of its own in confrontation with nature. Yet the beauty of the whole is not in the figure alone, but in the network of lines in which the figure is, to an extent, enmeshed.

Leaving aside Dürer's self-portrait as a boy (Plate 1), which, being his earliest surviving drawing, cannot be omitted from any such selection, we find that it is the lively pen sketch of the artist at about twenty (Plate 2) that furnishes us with the first well-defined image of the man's nature. This self-portrait, in which the artist looks out at us in such a strangely questioning manner, is an atmospheric picture with which nothing similar in earlier art can be compared; it throws a peculiar sidelight on the gravity of the man and the gravity of the age. It dates from his years of travel, presumably when he was on the Upper Rhine. His handling of the human body at that time is shown by the related drawing of a nude woman of 1493 (Plate 3), which has little articulation but makes a strongly sculptural impression because of its many curly and densely crossing lines.

Strange to say, such studies from nature are extremely rare, although one would think Dürer had portfolios full of them. It is possible that much has been lost, but in any case his copies of other works still meant more to him at that time than his own drawings from nature. He copied Italians— Mantegna, Pollaiuolo, Lorenzo di Credi—not as an incidental exercise in the styles of others, but in quest of formulas for coming to grips with nature. The Italian manner of stylizing the torso had an illuminating effect on him, and he passionately adopted the Italian motifs of large-scale movement and strong, pathetic expression. A drawing like his copy from Pollaiuolo, "Abduction of a Woman" (Plate 5), must have been all the more meaningful for him because of its obvious instructional purpose: the forward lunge position, borrowed from Greco-Roman models, is executed twice, in front and rear view. We do not know the original, but it was surely an engraving. Also lost is the model for the drawing of the death of Orpheus (Plate 4).

It can hardly have been the meager engraving preserved in the Hamburg Kunsthalle in a unique proof; we must presuppose a sheet with equally detailed draftsmanship, and we will not go wrong if we posit a work by Mantegna (F. Knapp). Dürer then mingled the individual elements of such compositions to form something new, without disguising the loan in any manner. In this way he created his engraving "Jealousy," in which the rear view of the nude from the "Abduction of a Woman" and one of the two women striking the bard in the death of Orpheus drawing (along with the child) are grouped together with yet another motif transferred from some other work. This is a procedure which we find simply incomprehensible today. The strength of Dürer's constitution is proved by his ability to "swallow these stones" without perishing. After all, he was really not at a loss for ideas of his own: what a rich plastic life there is in his 1496 drawing "The Women's Bath" (Plate 6)! And any one who was so well able to depict the impetus in the movement of jostling pigs as Dürer was in his sketch for the engraving "The Prodigal Son" (Plate 8) must have possessed great self-abnegation to become a pious student of foreign models.

The copies of Italian works do not prove that at that time (1494/95) Dürer had already made a trip to Italy, since after all he could copy engravings in his Nuremberg studio. Nevertheless other circumstances make such a journey seem probable. Among these is the existence of a few landscape sketches made on the Brenner road: at Innsbruck, Trent, Arco and other places. The possibility of dating these drawings as late as 1505, the year of the firmly documented major Italian journey, is ruled out in the case of most of them on stylistic grounds. The sketch of the citadel of Arco (definitely identified by Gerstenberg) reproduced here (Plate 14) should also be dated early. Quite surely, a finely detailed draftsmanship accompanied the large-scale outlines from the very start of Dürer's career. A similar drawing must have been made at that time at Klausen (near Bolzano); it was used in the larger engraving of "Fortune"—thus at any rate before 1505!

The great work of Dürer's youth, with which he immediately took his place in the front rank of German artists, was the woodcut series *The Apocalypse*. We possess no drawings directly connected with it. All the more valuable then is the searching study (Plate 7) of a man who reappears in many heads in *The Apocalypse* and who with his powerful forms can give us a clear notion of Dürer's conception of the ideal male during these years.

Additional light is shed on the development of Dürer's representation of movement by the drawing of a journeyman joiner (Plate 9) recently made known by Pauli. Related to the woodcut "The Martyrdom of the Ten Thousand," it fully possesses the great verve that can be sensed in the later woodcuts of *The Apocalypse*. Most of the *Great Passion* woodcuts belong to the same creative moment. (Since the authenticity of the journeyman joiner drawing is still doubted by some, we have inserted here a rapid pen sketch of excellent draftsmanship and unquestionable authenticity: the "snapshot" of Dürer's wife from the early days of their marriage [Plate 10].)

A different mood is created by the series of drawings that comes next, the so-called *Green Passion* of 1504 (Plate 11). To be sure, according to recent criticism (Cürlis) this famous series of green sheets must be dropped from the list of authentic works as a mere copyist's labor, but we are still repaid by a group of more or less finished drawings which the copyist used as his model. Along with more supple rendering and richer combinations of figures, the strokes have become more ornamental and transparent; if the magnitude of the conception is no longer as great as formerly, the drawing has decidedly gained in decorativeness.

Even more characteristic of the change are the woodcuts of *The Life of The Virgin*, the early part of which also dates from about 1504. We reproduce here a drawing of the birth of the Virgin (Plate 12), which varies quite a bit from the woodcut as executed, and is probably not far removed from Dürer's very first crystallization of the composition. We enjoy in it the spectacle of effortless discovery. The figures are grouped very naturally and the light and dark masses are spontaneously arranged. Where the painterly movement is in danger of flagging, the connection is carried out by one of the drapery motifs that are always at the artist's fingertips (on the bed). The unconstrained weightlessness of the composition makes the drawing decidedly superior to the richer woodcut.

The Life of the Virgin series contains the principal examples of the interweaving of the figures with the picture space. The viewer's eye travels from the individual figure motifs to their interconnections, and this is the true optical foundation for the success of a landscape picture. Such a drawing, of strangely poetic content, is the forest glade with a fountainhead (Plate 13), conceived as the scene of St. Anthony's visit to the hermit St. Paul. The small figures are altogether secondary in comparison with the land-

scape element, which in its decorative and spirited line work is reminiscent of individual sections of *The Life of the Virgin* and loses none of its charm for modern eyes if in places the forms are merely intimated.

With its meditative atmosphere, *The Life of the Virgin* forms a decided contrast to *The Apocalypse* and the *Great Passion* woodcuts, and one would be led to think that Dürer had suddenly become a different person. But this was not the case. He always had a feeling for the changeless and permanent, and perhaps he was more fond on the whole of description than of dramatic narrative. The very year in which *The Apocalypse* appeared, 1498, is also the year of the drawing of a man in armor on horseback (Plate 15), rendered with the objectivity of a costume historian. Two years later Dürer drew the Nuremberg costume studies (Plate 16), women's costumes, also completely precise and provided with descriptive captions. But it is most likely true: at the time of *The Life of the Virgin* his feeling for the individuality and essence of things becomes refined; the characters become more varied and more sharply defined; the artist's sensitivity permeates the minutest details. It was then (1503) that Dürer painted that picture of a piece of turf (Plate 16A*) in which he strove with endless pains to do justice to each individual in that microcosm. And a new feeling for skin and fur is evident in the 1502 drawing of a hare (Plate 17), which is connected with some other similar animal studies. The brush drawings of helmets with gleaming metal surfaces (Plate 18) also belong in this group.

But Dürer went further. Not content with external appearances, he sought, in human beings and in animals, the figure as it ought to be. There is no doubt that the master was most interested in those drawings which preserved the knowledge of the proportions of man and woman, the result of painstaking theoretical examinations. In Dürer's opinion, the artist is called upon not only to capture and retain the present moment by depicting it, but beyond this to give form to things which never reached reality or did so only in a corrupt state: to the pure thoughts of God. It is thus that we must view the figures of Adam and Eve (Plate 20), which then attained their final perfection in the 1504 engraving.

It affects us strangely to see how generality and individuality, calculation and observation, are brought into immediate contact. The very exact studies from nature of arms and hands (Plate 21) were later used directly

* [This illustration was reproduced in color in the German edition—S.A.]

[7]

in connection with the bodies that had been constructed schematically. In the precision of the drawing the arms and hands are close to those in the engraving, whereas the pleasant, light, but only superficial, line ripples of the entire figures are naturally far below the quality of the engraving. We find a substitute in the drawing of Apollo with the sun in his hand (Plate 19), a variant of the Adam figure, and one constructed from the same premises, but never engraved on copper. This is the very type of the completely detailed pen drawing. The line here, however, is not yet "clarified" —that is, filtered to achieve transparency.

The freshness of the portrait of Pirkheimer (Plate 22) leads us back to the domain of reality. Naturally it is one of a large group, but the other portraits interest us less than that of Pirkheimer, who after all was Dürer's best friend. At this time he supplied the funds for that (second) trip to Italy which the artist must have felt again and again to be an imperious necessity now that he was struggling with the depiction of the human form. In the autumn of 1505 he set out. If our interpretation is correct, the laughing peasant woman (Plate 23) with the legend "una Villana vindisch" (a peasant woman in the Veneto) is already a travel sketch from the South Tyrol [Alto Adige]. The merry head is fully modeled with lines that truly show the artist's enjoyment. The smile would no longer occur at a later date: interest in abiding form supplants the interest in expressive movement.

With the sojourn in Italy the drawings acquire a grander style. Form is seen in broader planes. Dürer becomes accustomed to soft brush drawings, which previously appeared only once in a while, and in the Venetian manner he uses colored paper with white highlights, so that the color of the paper gives the basic tone. And now the brush moves over the surface in long, moist strokes; but despite the unmistakable intention of competing with the tone harmony of Venetian drawings, ornamental line as such is still in evidence, and the connection with the traditional manner is more significant than the similarity to the new models. With unusual intensity Dürer now attacks the problem of drawing the body. Highly characteristic is the rear view of a female nude (Plate 24) with the energetic flow in the large-scale elevations and depressions of the sharply articulated form. (Dürer later modeled a small relief after this drawing—a sign of his high opinion of it.) The shaded areas are compressed into self-contained masses that are thrust away from the outer contour of the figure by reflection highlights. This is now Dürer's constant practice.

[8]

In the drawing of the nude Christ Child (Plate 25), a study for the Berlin *Madonna*, a strong dash of Florentine art is mixed with the Venetian impressions. The putto has little in common with Bellini's children; on the other hand, the prominent flesh folds and articulations are reminiscent of Verrocchio's school, and the head is especially close to Leonardo's manner. Contact with Leonardo's circle in Milan is also mentioned in connection with the small painting *The Young Christ Arguing with the Doctors* (Rome, Galleria Barberini) with its extremely exaggerated physiognomical studies. The marvelously expressive pair of boy's hands (Plate 27) is a drawing from this period; perhaps Dürer never came closer to the Italian ideal of beauty than here.

All that can be shown here in relation to Dürer's most important painting of his Venetian sojourn, *The Feast of Rose Garlands* (now in ruinous condition in Prague), is a portrait head of one of the participants, an old German architect resident in Venice (Plate 26). And yet Dürer has penetrated so deeply into the man's soul that he could easily occupy an entire painting by himself.

Pieces of this type must be recalled if the influence of the Italian journey is to be rightly assessed. Many people raise the lament that down there Dürer suffered psychic damage and lost the true warmth and love for all creation that he had previously possessed. Certainly in the immediately subsequent period there is a noticeable coolness. Interest in the world is confined exclusively to the figure, and the old wealth of form combinations, most clearly exhibited in *The Life of the Virgin*, yields to a more uniform, rigidly tectonic manner. But it would be unjust to deny that this limitation is accompanied by a gain in depth and energy. Such a composition as the coronation of the Virgin from the *Heller Altar* (1509) may perhaps be less likable than the earlier paintings in the style of the *Paumgartner Altar* (Munich) or *The Adoration of the Wise Men* (Florence), but the intensity with which the workings of the soul are seized has nevertheless grown more and more. Is it imaginable that before this time Dürer could have conceived a head with the concentrated power of that of the aged Apostle in the *Heller Altar* (Plate 31)? And in the sketch of a man looking upward (Plate 32), another study for this altarpiece, we encounter a depiction of noble emotion which is no ordinary achievement when one considers the petit-bourgeois tone of the religious paintings of the period. And with regard to the invention of forms, the thematic element, a single example

such as the drapery of St. Paul (Plate 28) is capable of shielding Dürer from the charge of derivative idealism. Here spirit has truly become form—and it is a new and mighty spirit.

The nude drawings no longer have all the freshness of those done in Italy. In the extremely cleanly modeled half-length nude study for the Christ of the *Heller Altar* (Plate 29) many viewers will admire Dürer more as a diligent and painstaking artisan (*Kläubler*) than as the transmitter of a direct impression of form. Dürer, however, must always be found wanting if he is judged from the viewpoint of an impressionist. Impressionism is precisely what he rejected. He eliminated any element in his style that led in that direction. The problem as he saw it was to combine maximum plastic clarity with a purely decorative *ductus*. In this sense the older generation was perfectly right in revering drawings such as the hands in prayer (Plate 33) or the feet seen from below (Plate 34) as the epitome of Dürer's art.

These are all brush drawings. Restrained and with little individual characterization, they are after all only final preparatory studies for paintings. The technique of the 1508 Lucrece (Plate 35) places it in this group; a comparison of this drawing with the Venetian rear view of a female nude (Plate 24) of 1506 will account for the opinion that Dürer's Italian drawings had greater freshness.

Alongside these, the drawings in chalk and charcoal do not belie the greater speed with which they were executed. These soft media, with their rapid effects, were especially appropriate whenever a portion of nature was to be captured in a brief sitting, above all therefore in portrait work. Thus the 1503 portrait of Pirkheimer (Plate 22) already shows the use of charcoal, although the masses of shadow are not yet exploited for a fuller painterly effect. Such masses were generally so employed in the other early drawings, and it would appear that Dürer also used his thumb to model surfaces. Now his artistic intentions no longer envisage these effects secured by wiping, and if the compact dark areas do not disappear altogether, still more and more the line becomes the dominant element. The dark clusters dissolve and the blacks are gradated in a more economical fashion.

The 1508 head of a Negro (Plate 36) is hard to categorize because coloristic intentions are present in it alongside the desire to model the forms. But a pronounced linear viewpoint becomes very clear in the 1514 portrait of the artist's mother (Plate 39) and the 1515 head of a girl (Plate

40). The emaciated forms of the old woman's head are expressed with great power in line, and it was out of the question for stronger, painterly shadows to compete with the force of the heavy strokes. The spirituality of conception of this arresting portrait would probably be matched by the 1518 head of Emperor Maximilian I (Plate 41), but the latter drawing has suffered much damage, and part of the interior lines are completely washed out. This portrait is related to several similar works. It is the years after 1520, however, that bring the richest crop of chalk drawings, and it would seem that only then did this technique achieve its fullest linear refinement.

In the middle period, too, the pen remains the artist's favorite instrument. He uses it for first drafts as well as for finished drawings, and when Dürer's drawings are spoken of as grand decorative linear systems, it is the pen drawings that first come to mind. Compared with the earlier period, the lines now become simpler. Line shading is more nearly confined to straight lines. Now there is a definite economy in the changes of line direction. Nothing can be found that does not seem dictated by the picture as a whole and effective as a partaker in the whole. The feeling for tone intervals becomes refined—what else would have been possible at the time when "Melancholy" and "St. Jerome in His Study" were engraved (1514)? The pen, however, does not compete with the delicacy of the engraved strokes, but limits itself to much simpler and more transparent line systems. A gradual enlargement of style is readily evident in the course of the 1510's: the line intervals become wider and clearer.

Our first example of the general characteristics of the middle period pen drawings is a study from a model, the 1514 "Seated Woman" (Plate 48), a fresh and direct copy from nature with priceless ease and felicity in the *ductus*.

With regard to the development of a compositional drawing from the earliest idea to the finished work, it is instructive to set up the following order:

1) "The Holy Family in a Room" (Plate 43). Example of the first statement of an idea. A few shading accents on the principal figure only. The placement of the masses in the space perfectly clear, however.
2) "The Madonna and Child on a Grassy Bank" (Plate 44). Somewhat more fully executed, but still merely a rendering of the first conception. Unusually telling example of the way in which figures and

[11]

landscape grow together as a decorative unit from a common conception.

3) "The Death of the Virgin" (Plate 45). Preliminary study for the woodcut from *The Life of the Virgin* (1510), but not the same as the print in every respect. In the woodcut the composition, lighting and line work were all simplified. Still, this drawing gives a good idea of the way in which woodcut effects are anticipated in preliminary sketches. Surely in most cases such detailed studies preceded the final drawing on the wood block, although a strikingly small number have been preserved.

Quite similar, but more advanced in style, is a 1511 "St. Jerome in his Study" (Plate 46), also a preparatory drawing for a woodcut. Since the print is the same size as the drawing, the latter is of particular value.

4) "The Adoration of the Christ Child in the Stable" of 1514 (Plate 47). Here the drawing is no longer merely a study, but a completed work of art in its own right.

This is also the period (1515) of Dürer's work on Emperor Maximilian's *Prayer Book* (Plates 49 and 50). Here the pen, not limited to naturalistic content, is given full freedom to enjoy all the rich possibilities of its activity. These margin drawings are witticisms of the pen whose infectious humor lies not only in objective depictions. It is strange enough that these drawings were designed to ornament a prayer book. This era, with its religious nonchalance, made no serious distinction between sacred and profane.

At about the same time the artist drew a couple of designs for goldsmiths (Plates 51 and 52), late Gothic applied art, all the more valuable for us in that Dürer was already acquainted with Italian forms, but nevertheless favored this native style with its free plant-form ornament. It is not only the naturalistic roots and branches of the bases that are borrowed from the vegetable kingdom, but above all the bowl (Plate 51), with its incomparably delicate linear movement and the contrast of its smoothness with the knobbiness of the base.

Immediately after the middle of the decade begins the movement toward what is magnificent, broad and energetic. These qualities are accompanied by strength and by the already heralded development of a heavy

stroke and wide line intervals. Typical are the freely sketched nudes (Plates 53 and 54) or the brilliant figure of a seated prophet (Plate 55) and, alongside these, but more simple in effect, St. Jerome in meditation (Plate 56) with the rigorous rectangularity in the figure and in the composition which is so well suited to the gravity of the situation. Among the elements of this stylistic trend, an occasional recurrence of sumptuous Venetian motifs is understandable, as in the 1519 Madonna (Plate 57) with her outspread drapery, the tapestry behind her back and the merry, music-making angel at her feet.

And yet it cannot be denied that this was a critical moment in Dürer's activity. His work was losing its power of immediate conviction. His energy was in peril of degenerating into superficiality, and his feeling for reality seems to have lost its warmth or to have acquired a strangely dry aftertaste. The artist, now nearly fifty, was saved from this danger by his long trip to the Lowlands (1520/21). He set out with his wife and maid, intending to see a lot and—with faculties trained over long years—to see it clearly. It is immediately evident how his vision revives. With silverpoint, in a small notebook format, he draws everything that meets his eye—heads, costumes, architecture—and always with the desire to be objective and exhaustive. There is no trace of the approximate or the impressionistic. He is most interested in people and personality (Plates 58 and 59). There is nothing similar to the Tyrolean landscapes of the early period. Instead, the traveler concentrates on precise depictions of architecture and topography. Very typical is the drawing of the Aix-la-Chapelle cathedral (Plate 60), which embraces the spacious foreground in the view.

Of equal importance for the new representation of space is the pen drawing of the shoreline of Antwerp, the Scheldedamm (Plate 61), perhaps only a redrawing of a silverpoint sketch. For an understanding of the development of Dürer's pen technique, it is not without interest to compare this rendering with the dense lines of the 1510 landscape (Plate 42).

Pen portraits drawn in a similarly open manner are not lacking, but the most characteristic feature of the last period is the large-scale chalk portraits, in which Dürer handles the medium with consummate mastery. All these heads are placed firmly and surely, with emphasis on horizontals and verticals, with narrow margins and, when the drawings are finished in quality, with a total purity of line.

Surprisingly, the stylization of the individual elements is not always

the same. For example, the hair and clothing are sometimes treated quite differently from the flesh, more decoratively and cursorily, whereas, on the other hand, the drawing of the animated sections tends to surpass anything previous in its naturalistic delicacy. Dark areas are not completely ruled out, but are almost never used coloristically; they are tolerated only to indicate shadows. The hair of the 1520 drawing of a young man (Plate 62) is not left in white to indicate blondness, but is simply viewed as neutral in color tone, the concept of linear drawing being interpreted more rigorously.

In contrast to this, the eyes and hair in the so-called Lucas van Leyden portrait (Plate 63) have a decidedly coloristic effect, but the hat participates in this color feeling just as little as the jacket. A later portrait, like the splendid one of Ulrich Varnbühler (Plate 64), which also exists as a woodcut, is once again strictly linear; here considerations of transfer to the wood block may have been a determining factor from the start. Brush drawing recurs alongside chalk drawing in rare cases. One instance is the superb portrait of an old man of Antwerp (Plate 65), who must have sat long and patiently. This head was used for the Lisbon painting of St. Jerome. When compared with the brush studies of the middle period, however, this drawing shows quite clearly how Dürer now strives to keep the highlights together in greater masses. They interlock and are no longer placed in isolation on the ridges of the plastic form. This painterly effect is especially expressive in the old man's beard, which nevertheless still adheres completely to the principle of linearity.

The same must be said of the 1521 brush drawing of drapery (Plate 66)—an instructive contrast to the draperies of the *Heller Altar*.

In this period, however, the preliminary studies for figures in paintings are generally no longer entrusted to the brush, but to chalk or to a lead-like metal point. These studies for paintings are characterized by an especially delicate, sometimes "toned down" modeling. Thus the drawings of a weeping putto (Plate 67), the Man of Sorrows, and St. John lamenting were intended for use in paintings. If in the body of the Man of Sorrows (Plate 68) the new delicacy of naturalistic feeling has acquired an arresting form, the St. John lamenting (Plate 69) is a higher manifestation of the expressive and agitated figures of the Apostles at the sepulcher in the *Heller Altar*. Here everything is of a piece, body and drapery, and both are completely shaped by the inner feeling, by the demands of psychological expression.

The paintings for which these were the studies were never executed. Our image of Dürer would surely be quite different if even a few of his plans for paintings in his late years had been realized. These are the ideas of the man who had returned from foreign lands with his soul powerfully developed and now, back in Nuremberg, in gravity and grandeur, was taking stock of his life. It was not to last much longer. He died in 1528.

The only paintings from this period that we possess are the two groups of two men each known as *Apostles* and dating from 1526 (Munich). But the compositions with many figures and rich plastic life were not carried out. An approximate notion of the rhythm that now infused Dürer's imposing groups can be gained from the 1521 sketch of the Madonna with saints and angels (Plate 71), in which a grandiose symmetrical theme (the Madonna enthroned between two widely separated music-making angels) is, in a completely new fashion, transmuted into an asymmetrical design (three of the four saints are to the left of the Virgin, the architecture achieving the equilibrium). It cannot be proved, but it is likely, that the 1522 "Lamentation" (Plate 70), so full of substance, is also to be considered as a study for a painting; whereas the immediately preceding pen drawing of a "Lamentation" of 1521 (Plate 72) is decidedly graphic in nature.

Then once again Dürer took refuge in the woodcut to set down the wealth of ideas pouring in upon him. Once again he wished to speak to all men in the popular language of the woodcut, and the large *Passion* series in oblong format that he was preparing could have been a worthy counterpart to the *Apocalypse* of his earlier years. But only a single subject, "The Last Supper," was cut in wood. A few other scenes are preserved for us in drawings. Here Dürer seems to have striven more conscientiously than before to achieve maximum expressiveness. Nothing was to have a formal effect, everything was to be objective and simple. This simplicity, however, is not archaic, but goes hand in hand with the exploitation of all artistic means, so that these drawings are unique in the richness of their effect. Of the two representations of "Christ on the Mount of Olives," the earlier one (Plate 73) sets out from the image of lying prone and arranges the entire composition in accordance with the motif of complete self-surrender, whereas the later one of 1524 (Plate 74) shows the moment at which Christ throws his hands upward; it is magnificent, how this gesture is led up to from a distance by the curve of the sleeping Apostles. Even the scene of "The Adoration of the Wise Men" (Plate 75), usually so cheerful, has now

[15]

acquired a curious solemnity and gravity: the group of Mother and Child is one of severe and controlled dignity, and the kings, real kings (the one in the middle!), are imbued with the sacredness of the occasion. This work exhibits with particular clarity the richness of Dürer's final drawing style: by the simple means of changing the direction of the line clusters while keeping the line intervals equal, Dürer achieves the impression of an extremely vivid shimmering of different types of surfaces.

Not only narratives, but even representations of purely ritual acts like the consecration of wine and bread by the priest, partake in the general elevation of mood (Plate 76). The arrangement in simple planes of the figures, which are interconnected by economically placed accents, gives this priceless drawing a truly monumental effect. In order to evaluate properly the significance of this work, it is necessary to compare it with similar scenes in *The Life of the Virgin*.

Finally, when the element of strenuous movement is added, completely new and surprising vistas open out. The five nude figures of 1526 (Plate 77), significant in their own right and significant in the method of their interconnection, are probably a study for a Resurrection. Here, within the boundaries of Dürer's art, the extraordinary nature of the event is matched by an extraordinary pictorial effect.

Of the last two drawings included here (Plates 78 and 79) it is not quite certain that the first, a color study of vegetation, really belongs to this very late period—the date 1526 cannot be considered authentic—but in the perfect clarity of its plastic execution it nevertheless presents a characteristic contrast to the more painterly experiments of the early period (compare "The Piece of Turf" [Plate 16A], on which the date 1503 is said to appear). At the same time, this drawing also reminds us where the roots of Dürer's power lie: the greatness of the Apostle would carry less conviction if Dürer's sensibilities had not always been equally alert to the small and inconspicuous things of the earth.

It cannot be doubted that the present generation is moving away from Dürer. The young Dürer is prized, but the masterly artist forfeits the interest of our time as he increasingly champions the total clarification of form as the first principle of art. Critics express regret that he lost his immediacy of vision, and that the many painterly promises of his early period were not

fulfilled. They seek in drawings not correctness but impulsiveness independent of correctness. They would gladly trade in the greatest figure compositions in the Italian style for a few landscapes like the twilight scene with the "*Weiherhäuschen*" (Frontispiece).

This contrast is an old one and dates back to Dürer's time. Grünewald, the young Cranach and Albrecht Altdorfer were painting at the same time as Dürer, and their art was different from his. Compared with the amazing expressive power of Grünewald, who is not afraid of any "uncorrectness" if it served his atmospheric purpose, Dürer may well appear somewhat academic. And certainly Grünewald had a greater feeling for color and texture: alongside his drawings Dürer's line has practically only a neutral beauty. The trees in Cranach's early engravings reproduce the natural phenomena more fully than Dürer's trees; not right at the beginning, but soon, Dürer strives for a more abstract rendering of form. Landscapes like those sketched by Altdorfer or Wolf Huber come alive for us as passionate and fiery impressions, full of a great permeating movement; Dürer in his youth had the desire to do similar things, but then even here he became a constructor, an educator, an organizer. In all things he sought not the changing phenomenon, but the enduring form.

His guiding thought was a pedagogic one, to teach German art to acquire clarity of language. It must be conceded that this meant the loss of many values. But history has recognized this effort as a great and necessary one, and the glory of Dürer's draftsmanship has cast Grünewald into oblivion.

HEINRICH WÖLFFLIN

I SELF-PORTRAIT AT THE AGE OF THIRTEEN. 1484
Silverpoint. Albertina, Vienna. 275 × 196 mm; $10\frac{13}{16}$ × $7\frac{11}{16}$ in.

The handwritten legend reads: "Dz hab ich aws eim spigell nach mir selbs kunterfet im 1484 Jor do ich noch ein Kint was. Albrecht Dürer" (I drew this picture of myself from a mirror in 1484, while I was still a child. Albrecht Dürer).

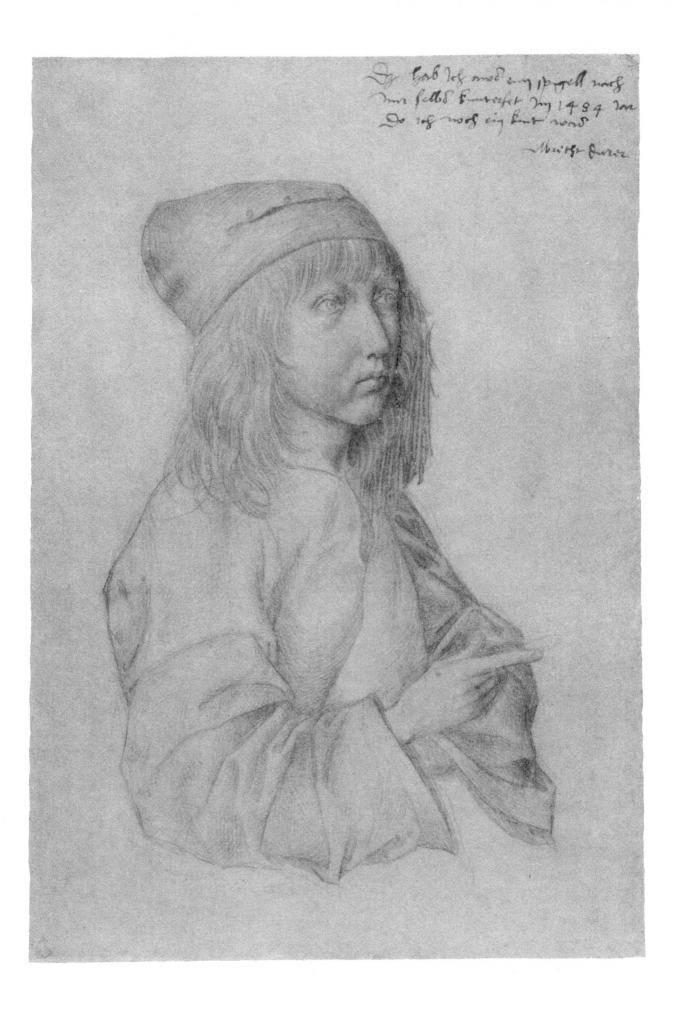

2 SELF-PORTRAIT. Ca. 1491

Pen. Universitäts Bibliothek, Erlangen. 204 × 208 mm; 8 × 8$\frac{3}{16}$ in.

The identity of the features with those in the self-portraits confirmed by inscriptions is completely convincing. Dürer's conception of form is especially clear in the rendering of the hand (it is the mirror image of the left hand; the right hand, which is executing the drawing, is omitted). This is an important example of the expressive head, an introduction to the great art that is to come.

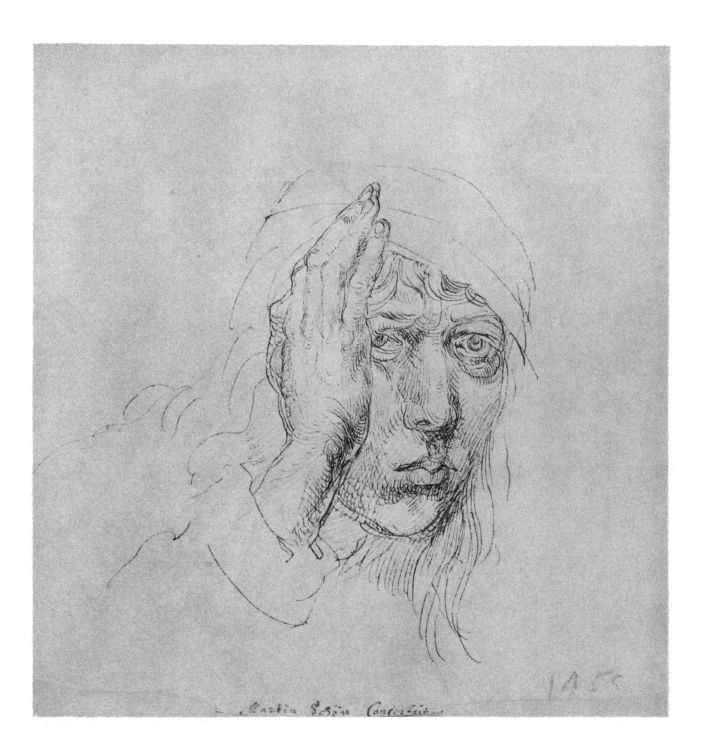

3 FEMALE NUDE (WITH HEADCLOTH AND SLIPPERS). 1493
Pen. Musée Bonnat, Bayonne. 272 × 147 mm; $10\frac{3}{4} \times 5\frac{13}{16}$ in.

This finished study from nature shows the density and lack of clarity of the line work in the shadow areas that are characteristic of the early period. The approach is much more painterly than it will be later (for example, in the eyes).

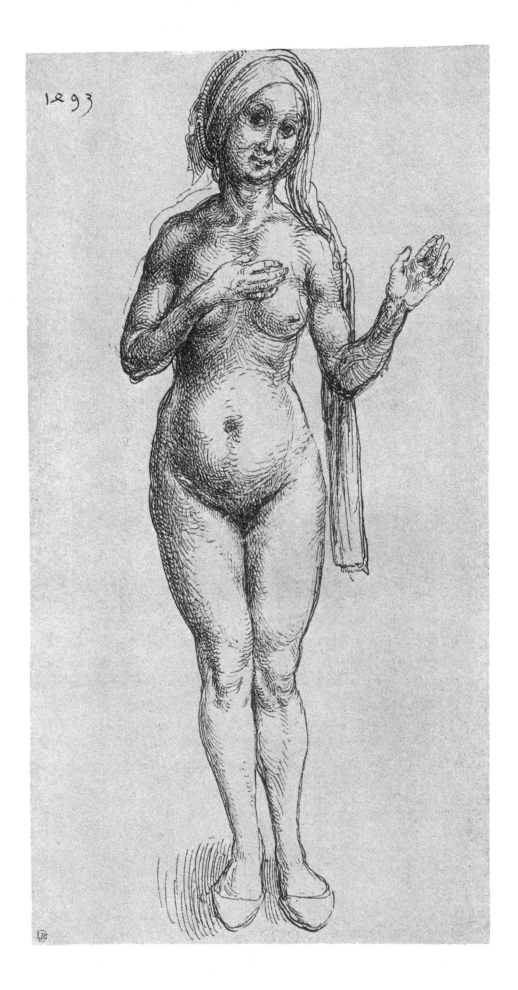

4 ORPHEUS SLAIN BY BACCHANTES, WITH A BOY RUNNING AWAY. 1494
Pen. Kunsthalle, Hamburg. 289 × 225 mm; 11⅜ × 8⅞ in.

This is a copy of an Italian work, presumably by Mantegna, who in his turn was using Greco-Roman models. The landscape, the details of the drapery folds and the handling of the line in general are worked out in a quite independent fashion. In the tree a banderole with the legend: "Orfeus der erst puseran" (Orpheus, the first pederast). The woman at the left and the boy were used by Dürer a few years later in the engraving known as "Jealousy" (more correctly "Chastity and Unchastity").

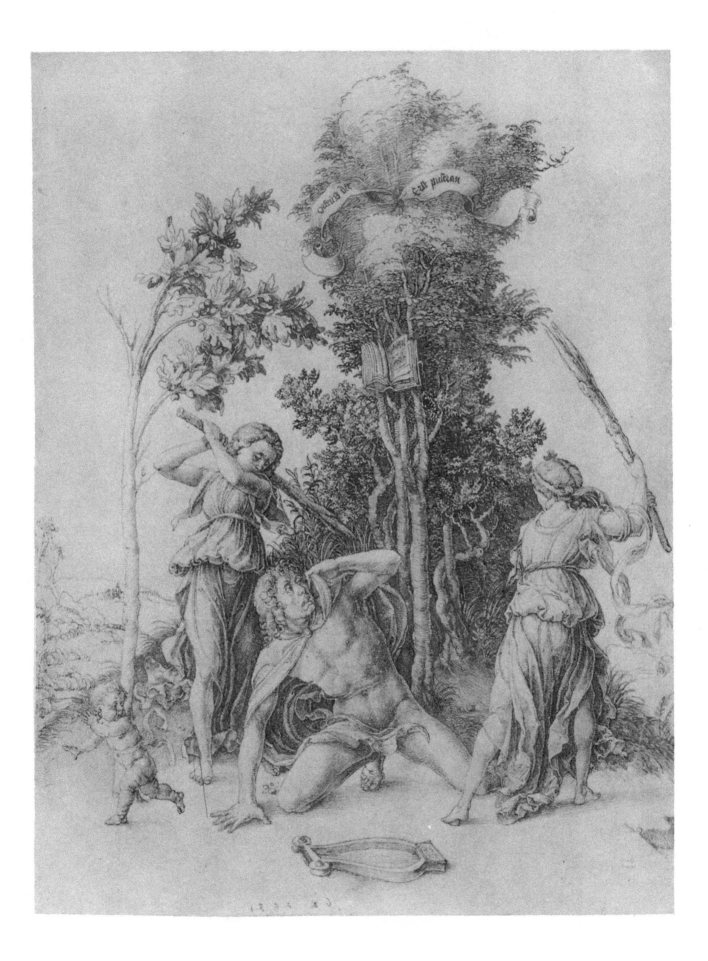

5 ABDUCTION OF A WOMAN (RAPE OF THE SABINE WOMEN). 1495
Pen. Musée Bonnat, Bayonne. 283 × 423 mm; 11⅛ × 16⅝ in.

This copy of a (lost) engraving by Antonio Pollaiuolo shows the lunge position in front and back view. The important element for Dürer was not the mere representation of the activity, but the basic Italian method of rendering articulation of the body. Dürer allowed himself freedom in individual details. He was surely not able to borrow from his original the manner in which the modeling lines follow the form, and the contour also has become gnarled in Dürer's fashion. The rear view of the male nude recurs in the engraving "Jealousy."

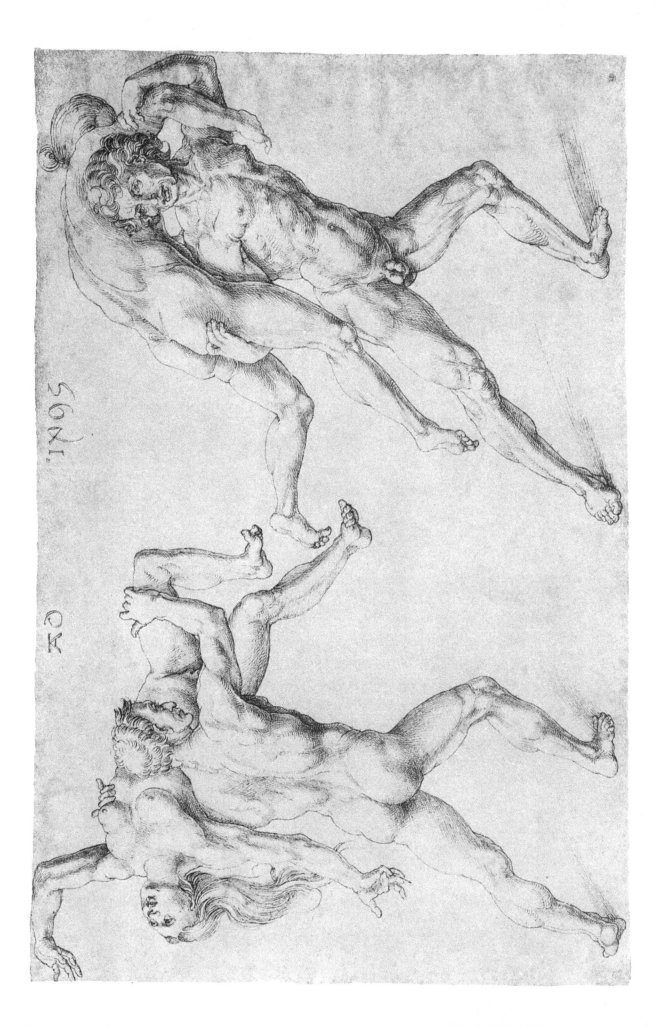

6 THE WOMEN'S BATH. 1496

Pen. Kunsthalle, Bremen. 231 × 226 mm; $9\frac{1}{16}$ × $8\frac{7}{8}$ in.

Weak in its perspective and not yet quite clear in its representation of forms, this drawing nevertheless possesses significant qualities: a strong feeling for corporeality and for rich configuration. Form is suggested by light, jumping strokes of the pen, with the vagueness typical of the early period. A painterly effect is sought in the darkness of the wall and ceiling, in which the grain of the wood is disproportionately emphasized, as in the art of the primitives.

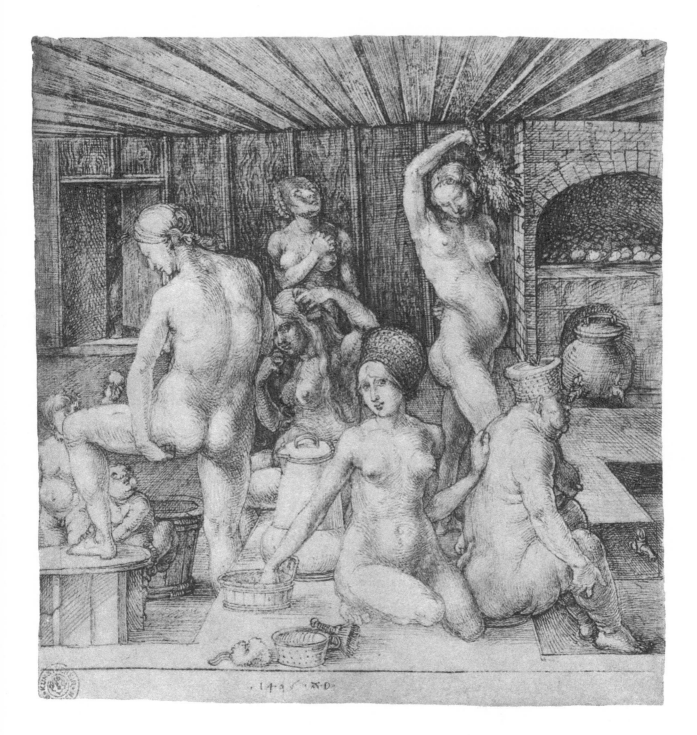

7 WINGED MAN, IN IDEALISTIC CLOTHING, PLAYING A LUTE. 1497
Silverpoint on dark paper, with white highlights. Kupferstichkabinett, Berlin.
268 × 195 mm; $10\frac{9}{16} \times 7\frac{11}{16}$ in.

The statuesque model was also available to the artist during his work on " The Apocalypse." In that series the head recurs not only in the destroying angels, but also in the apocalyptic horsemen and the angels that calm the winds.

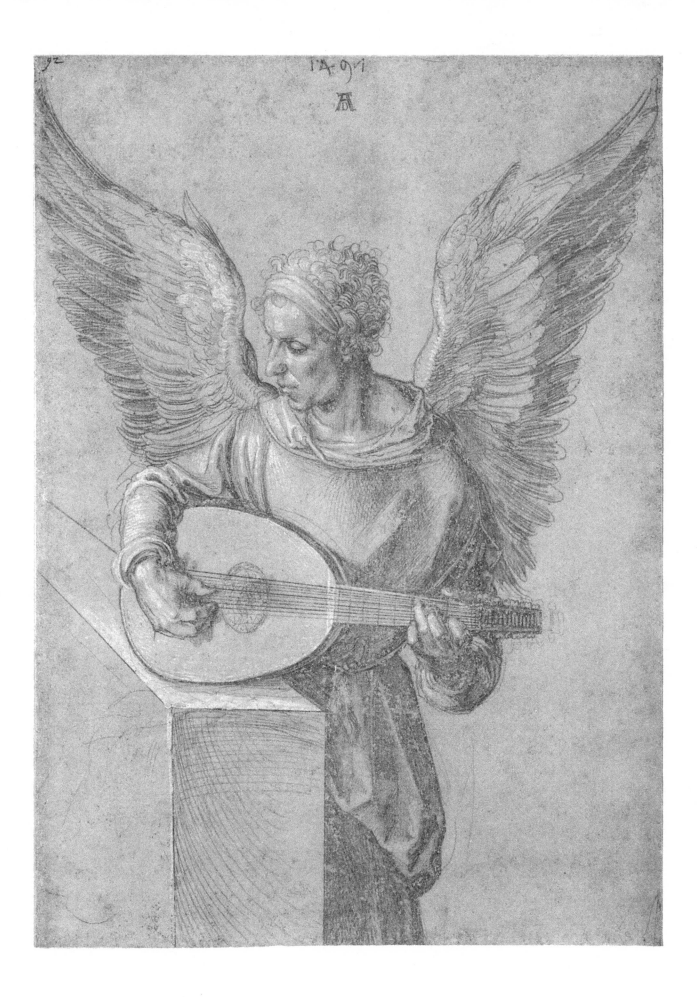

8 THE PRODIGAL SON AMONG THE SWINE. 1497/1498?

Pen. British Museum, London. 217 × 219 mm; $8\frac{9}{16}$ × $8\frac{5}{8}$ in.

The sheet, which is cut at top and bottom, is a preliminary drawing for the (also undated) copperplate engraving, which may be assigned to 1497/98. In the engraving the houses were brought lower, the figures were brought closer together, and the best pig (the one with its feet in the trough) was omitted. The praying swineherd, whose bodily articulation is not easily discernible even in the drawing (the springing of the left leg!) became more unclear in the engraving. Such cases are important for the proper evaluation of the more mature master's efforts for complete clarity of representation.

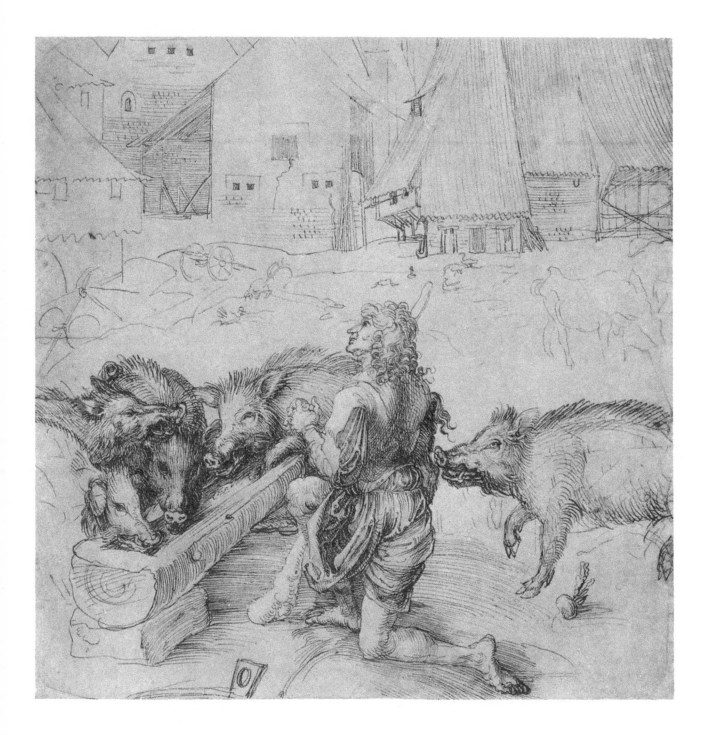

9 YOUNG MAN LEANING FORWARD AND WORKING WITH A LARGE DRILL [JOURNEYMAN JOINER].

Pen. Musée Bonnat, Bayonne. 251 × 151 mm; $9\frac{7}{8}$ × $5\frac{15}{16}$ in.

This splendid action figure was used in the woodcut "The Martyrdom of the Ten Thousand." The monogram and the date 1518, much too late for this drawing, are not authentic.

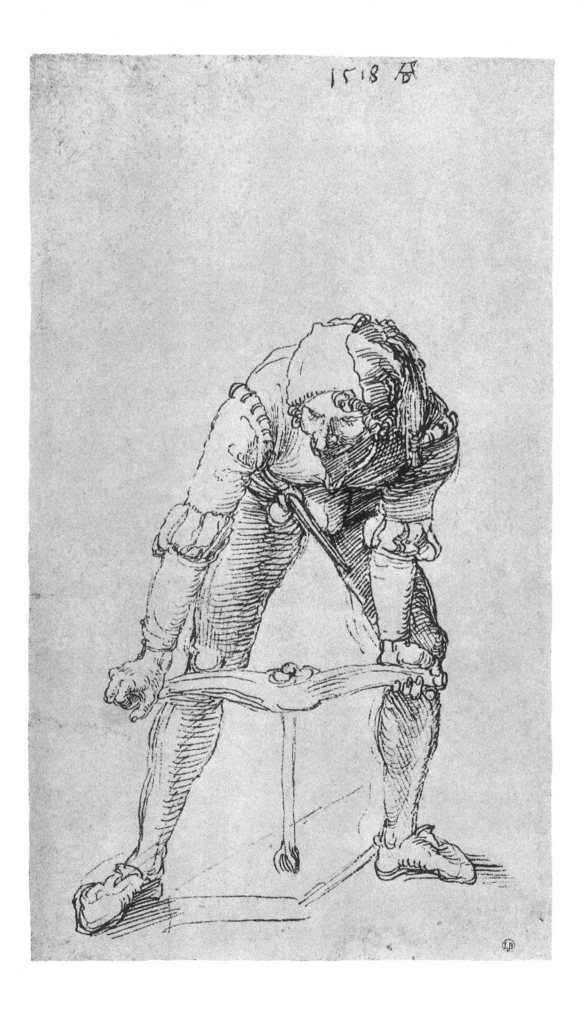

10 DÜRER'S WIFE AGNES.

Pen. Albertina, Vienna. 156 × 98 mm; $6\frac{1}{8} \times 3\frac{7}{8}$ in.

Below, the legend "Mein Angnes" and the (later) monogram. Compare with this portrait from the early period of the marriage the later one, Plate 58. The heavy eyelids and the protruding eyes are characteristic facial elements. The untidy hairdo occurs in other depictions of Agnes and seems to have been a constant feature of her appearance.

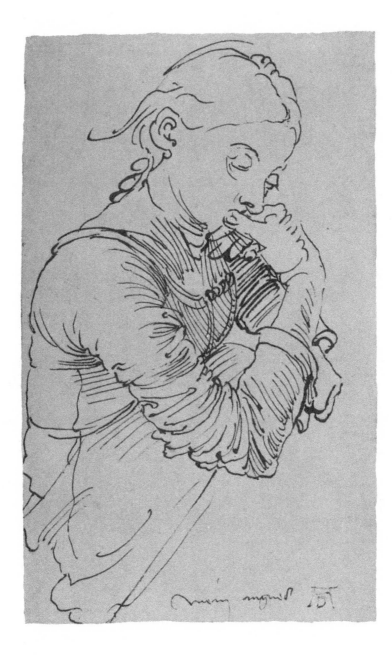

11 CHRIST CROWNED WITH THORNS. 1504

Pen. Albertina, Vienna. 253 × 180 mm; 10 × 7$\frac{1}{16}$ in.

In this finished drawing the architectural lines were executed with compass and ruler. This was part of a Passion series which is preserved in its entirety only in a copy on green paper by another hand, the so-called "Green Passion" (also in Vienna). See introduction.

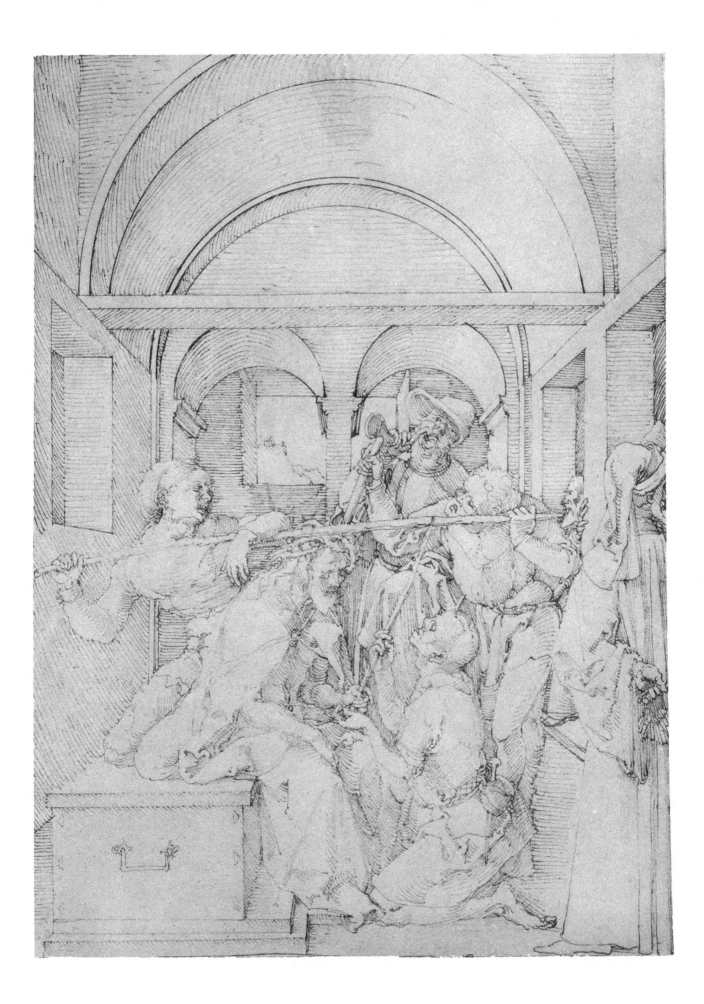

I 2 Lying-in room.

Pen. Kupferstichkabinett, Berlin. 288 × 215 mm; $11\frac{5}{16}$ × $8\frac{7}{16}$ in.

This is a sketch for the composition of " The Birth of the Virgin" in the series " The Life of the Virgin." The figures and the space they occupy are even simpler than in the woodcut, but have the fresh charm of a first draft. The bed still fills the whole width of the room and the main action is the infant's bath. The late Gothic furniture deserves special attention. The composition as a whole is still schematic, but the essential play of light and forms is already fully effective.

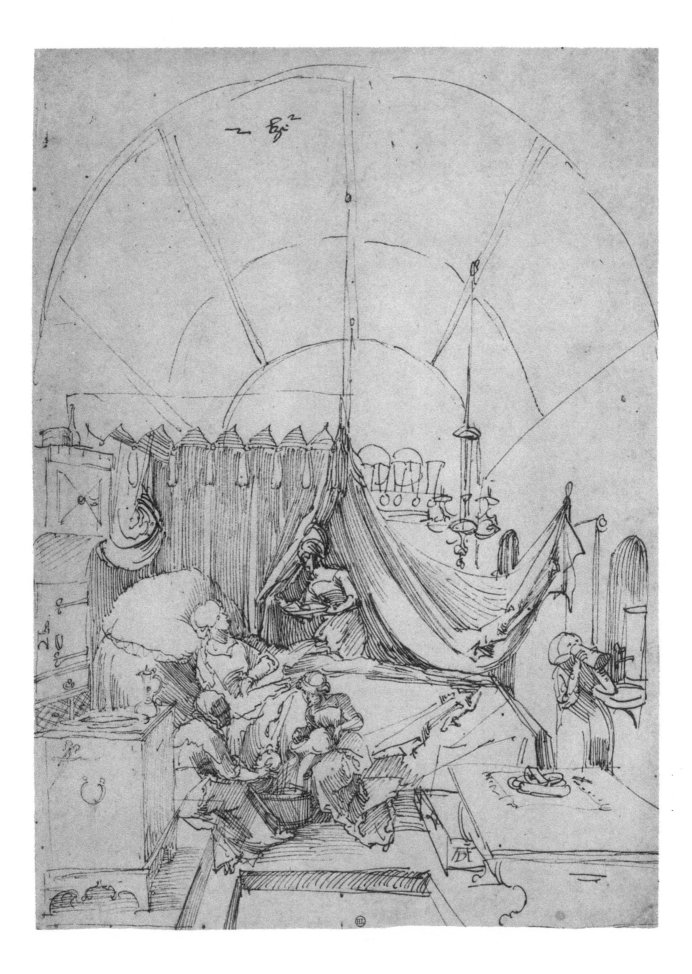

1 3 FOREST GLADE WITH A WALLED FOUNTAIN BY WHICH TWO MEN ARE SITTING (ST. ANTHONY AND ST. PAUL, IDENTIFIED BY THE FLYING RAVEN). Ca. 1505

Pen. Kupferstichkabinett, Berlin. 186 × 186 mm; $7\frac{5}{16} \times 7\frac{5}{16}$ in.

This is a pure landscape, finished only here and there, painterly in character, and surpassing even the landscapes in "The Life of the Virgin." Executed about 1505.

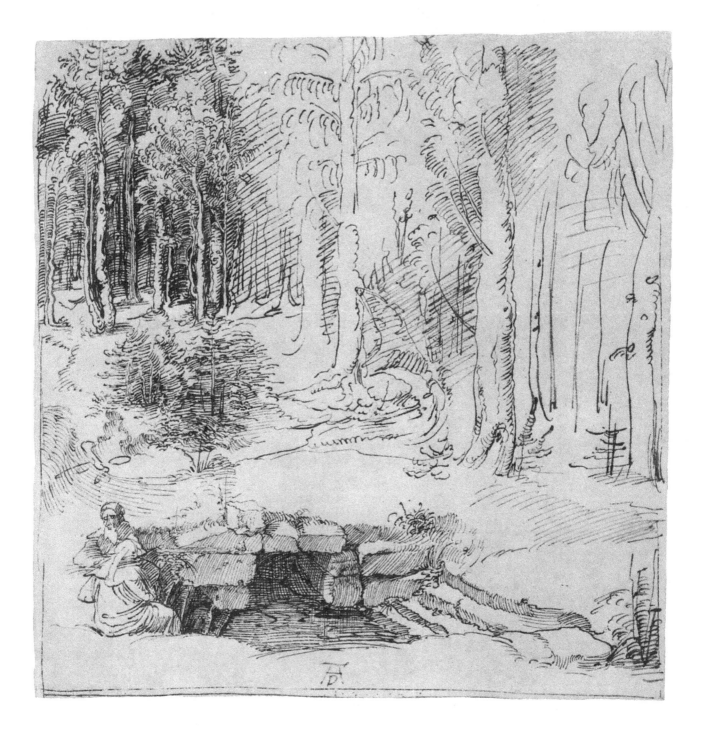

14 THE CITADEL OF ARCO IN THE SOUTH TYROL.
Watercolor over preliminary pen work. Louvre, Paris. 222 × 221 mm;
$8\frac{3}{4}$ × $8\frac{11}{16}$ in.

*This sheet combines drawing of metallic sharpness (in the buildings) with a
curiously soft painterly rendering (the shimmering olive trees). The legend reads:
"Fenedier klawsen" (fort in the Veneto). On the question of the dating, see the
introduction.*

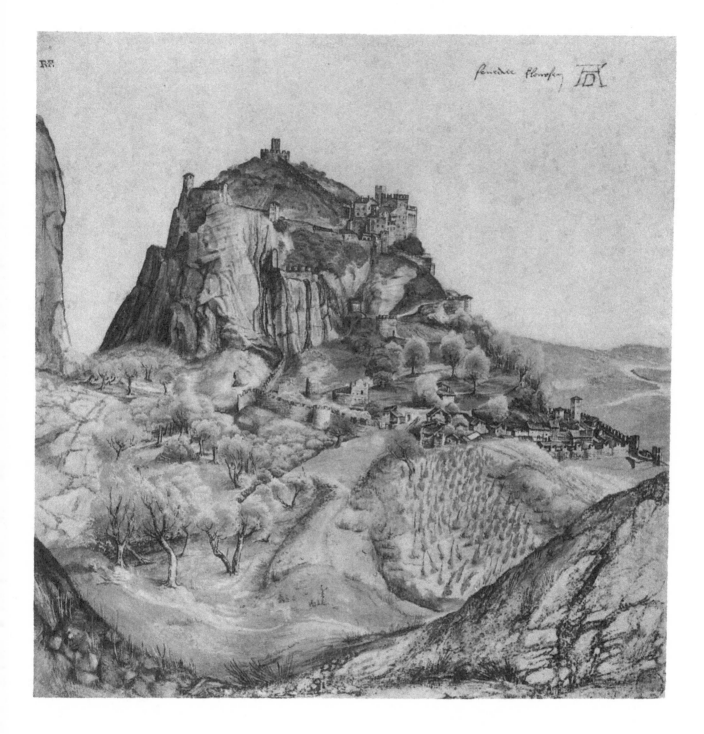

15 MAN IN ARMOR ON HORSEBACK. 1498

Watercolor and pen. Albertina, Vienna. 410 × 324 mm; $16\frac{1}{8}$ × $12\frac{3}{4}$ in.

The legend reads: "Dz ist die Rustung zu der Zeit im Tewtzschlant gewest"
(This was the armor at the time in Germany). Fifteen years later the knight was
transferred almost unchanged to the engraving "Knight, Death and Devil," but
was there seated on a different horse, one of Italian construction.

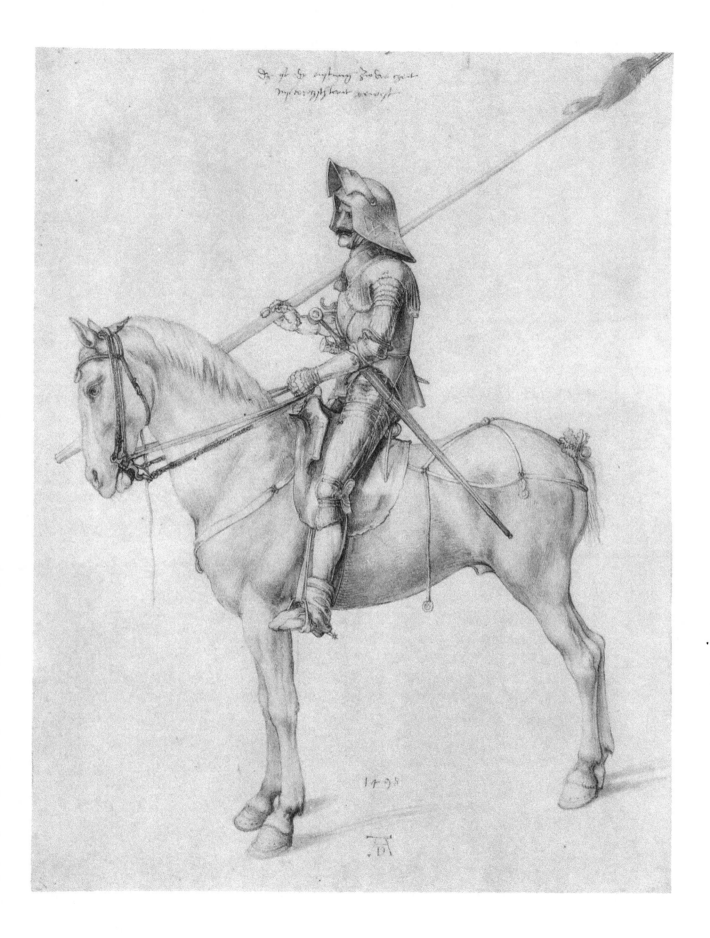

16 A NUREMBERG COSTUME STUDY. 1500

Pen and watercolor. Albertina, Vienna. 325 × 218 mm; $12\frac{13}{16}$ × $8\frac{9}{16}$ in.

The legend reads: "Also gand dye Nörmerger frowenn zum thantz" (This is how Nuremberg women go dancing). Analogous costume sketches are used in "The Life of the Virgin." The predominance of vertical motifs is characteristic of the costume style. Compare the change of emphasis favoring the width, with strong horizontal divisions, evident a half generation later in Holbein's depictions of women's clothing in Basel.

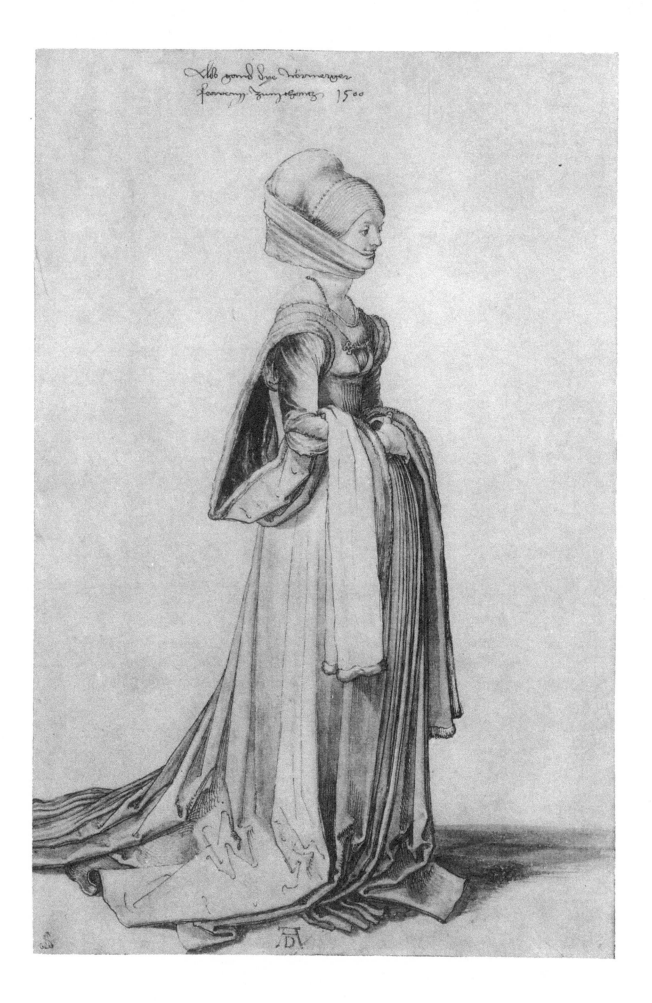

16A THE SO-CALLED GREAT PIECE OF TURF. 1503

Watercolor. Albertina, Vienna. 412 × 315 mm; $16\frac{3}{16}$ × $12\frac{7}{16}$ in.

This picture of the impenetrable vegetation of a meadow is an odd attempt to master an infinity of small forms. It parallels the similar treatment of human beings in action, especially evident in " The Life of the Virgin." After the major trip to Italy this no longer occurs.

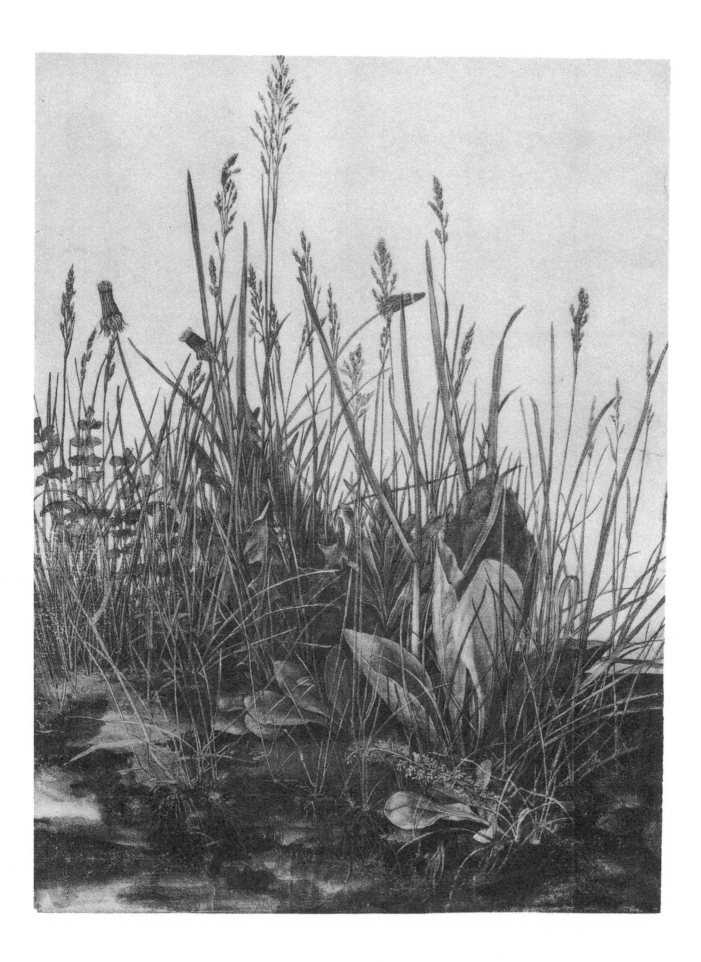

17 YOUNG HARE. 1502

Watercolor with opaque white. Albertina, Vienna. 251 × 226 mm; $9\frac{7}{8}$ × $8\frac{7}{8}$ in.

This much-admired drawing is significant not merely as an isolated masterpiece.
Dürer, who always had a love for hair and fur, naturally rendered these
phenomena in increasingly linear fashion.

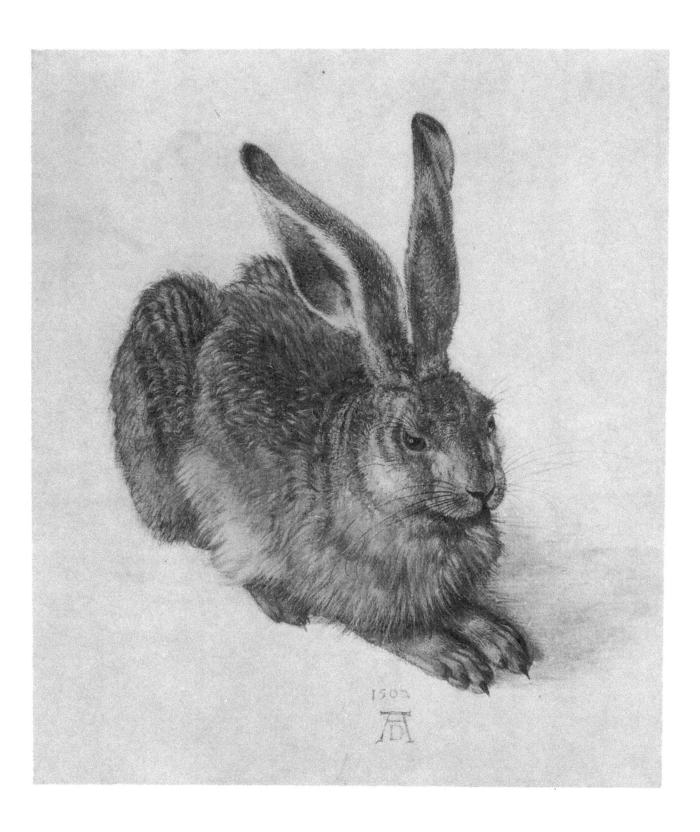

18 SIDE, FRONT, AND BACK VIEW OF A HELMET.
Pen. Louvre, Paris. 422 × 268 mm; 16⅝ × 10 9/16 in.

The date 1514 is false. Dürer apparently owned the helmet. The side view was used in the 1503 copperplate engraving " The Coat-of-arms of Death," the front view in the engraving (to be dated not much later) " Coat-of-arms with a Rooster."

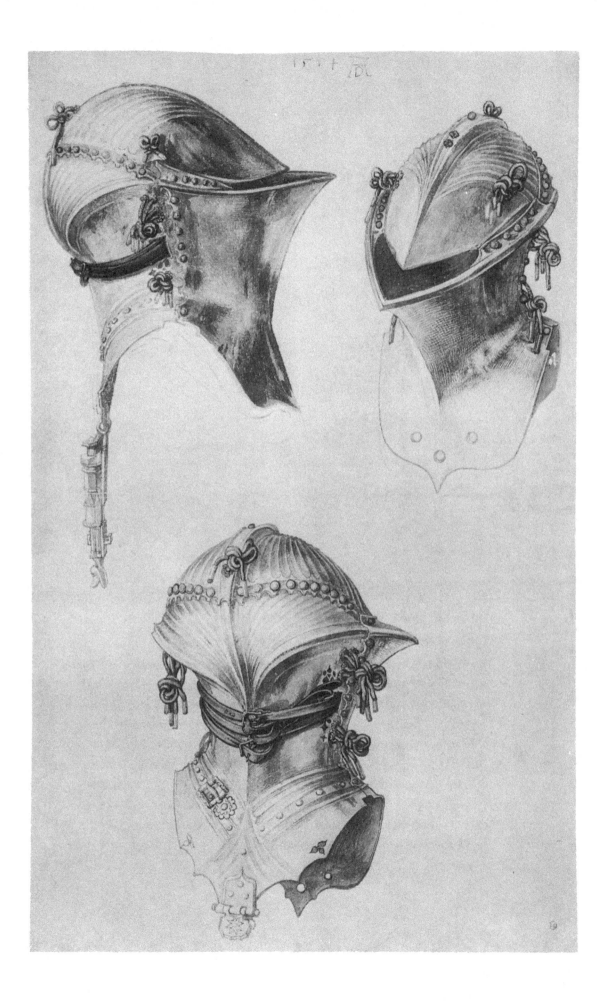

19 APOLLO WITH THE SOLAR DISC AND DIANA TRYING TO SHIELD HERSELF FROM THE RAYS WITH HER UPLIFTED HAND.

Pen. British Museum, London. 285 × 202 mm; 11¼ × 7¹⁵⁄₁₆ in.

This variation on the Adam of the 1504 copperplate engraving was also conceived originally as a print, but was not engraved. The Adam of the print is more felicitous because of the contrast supplied by the turning of his head away from his extended free leg. The present drawing is finished to a great extent but not yet fully refined. The celestial background, rich in painterly effect, was added at a later stage. The original purpose was the depiction of the male figure alone, who represented the planetary god Sol (Panofsky). The rendering of the sun's rays is extremely noteworthy. The word "Apolo," written backwards with a view toward the engraving, is probably a substitute for the earlier name Sol; this would explain the conspicuous incongruity of the inscription and the space allotted to it.

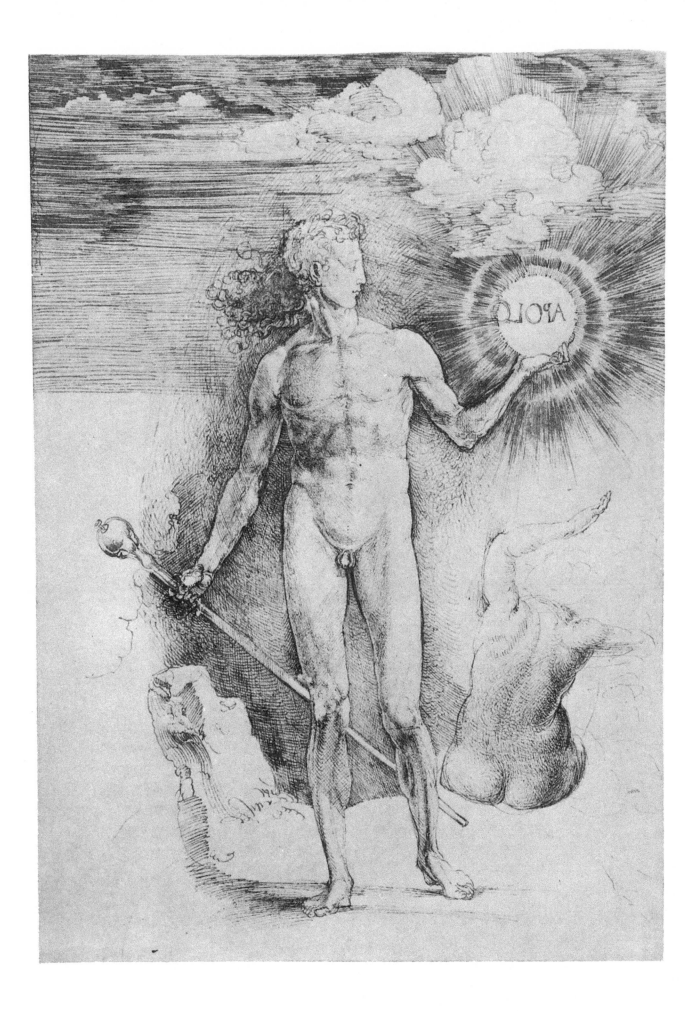

20 IDEALISTIC MALE AND FEMALE FIGURES [ADAM AND EVE]. 1504

Pen. Morgan Library, New York. 242 × 201 mm; $9\frac{9}{16}$ × $7\frac{15}{16}$ in.

This is an extremely finished preliminary drawing for the copperplate engraving "Adam and Eve." The bodily proportions were the result of theoretical studies. To bring the relationships into greater prominence, the background is tinted black. The engraving shows small variations in details, especially of lighting (in both of Eve's arms), but the main difference is that although the limbs are in the same attitude the gesture has won a new significance. In the drawing Adam is also holding an apple and with her free hand Eve is making a "fig" (R. Wustmann). This drawing is a primary example of the "ornamental" linear style. Compare the still weak and unclear line work of "The Women's Bath" (Plate 6). On the copperplate, in accordance with the new material, the modeling line was handled quite differently again.

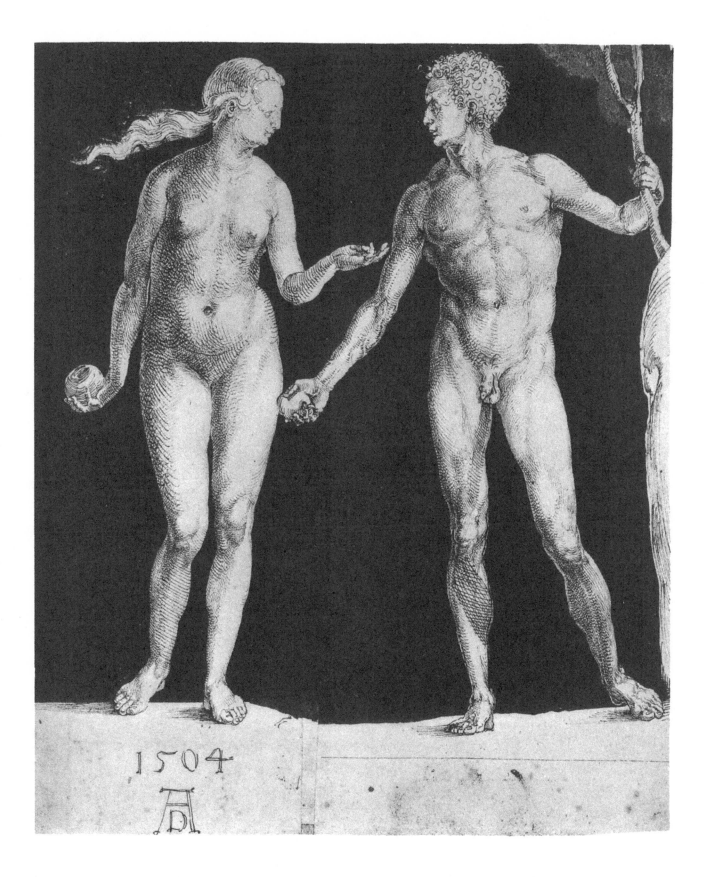

21 THREE STUDIES FROM NATURE FOR ADAM'S ARMS IN THE 1504
COPPERPLATE ENGRAVING.

Pen. British Museum, London. 216 × 274 mm; 8½ × 10$\frac{13}{16}$ in.

The left arm [= the right in the engraving] appears immediately in its permanent form, but the final form of the right arm is found only in the second, larger drawing. For the hand, however, the (cupped) hand in the middle of the sheet was accepted for the final execution.

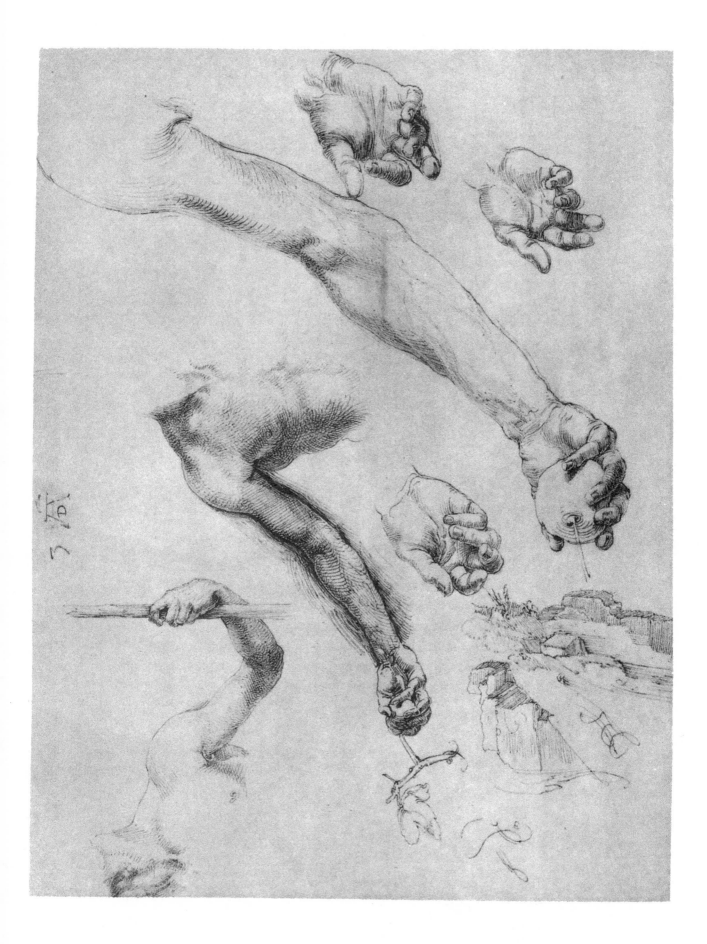

22 WILLIBALD PIRKHEIMER. 1503

Charcoal. Kupferstichkabinett, Berlin. 282 × 208 mm; $11\frac{1}{8}$ × $8\frac{3}{16}$ in.

This was obviously a quick sketch, but even a longer working period would not have essentially modified the style of the drawing, although this is true of the later drawings. Here the dark areas are still grouped in compact masses, most strikingly in the cap, but also in the ear and hair. There is no visible inclination for distinguishing these features by means of line.

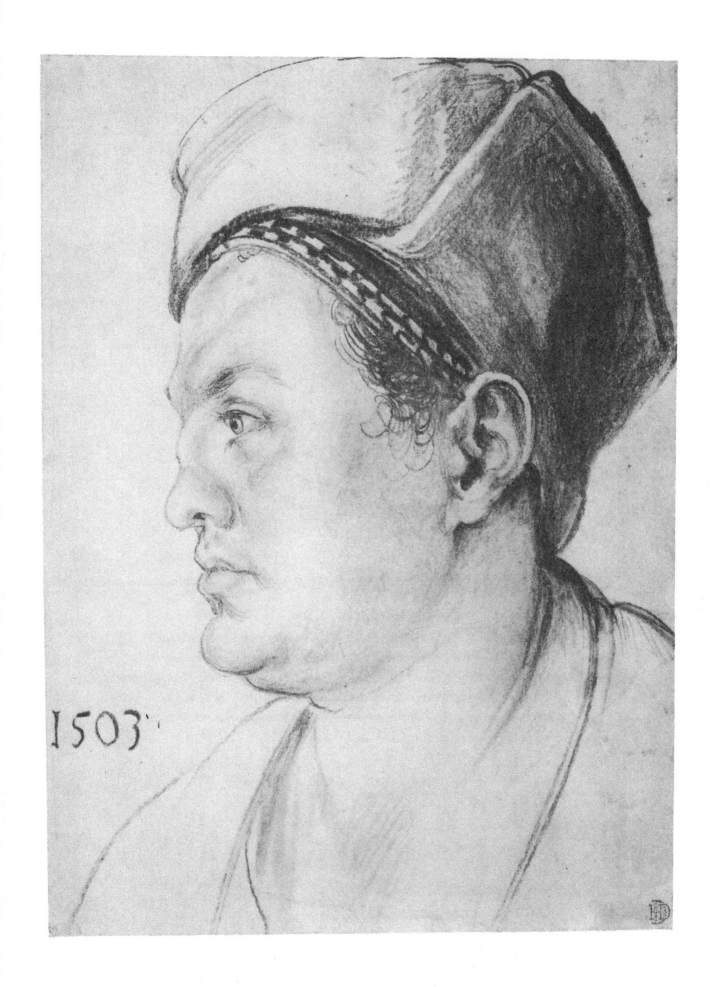

23 LAUGHING PEASANT WOMAN. 1505

Pen. British Museum, London. 390 × 270 mm; $15\frac{5}{16}$ × $10\frac{5}{8}$ in.

The legend reads: "una Villana vindisch" (a peasant woman in the Veneto).
This shows the delicate short strokes of the time of "The Life of the Virgin,"
still without more rigorous economy: a flow of little dashes, crossed here and there
by patches of straight lines that extend beyond the outlines of the forms; a
chiaroscuro effect. The transitory moment of the drawing back of the lips and
the blinking of the eyes is captured and retained.

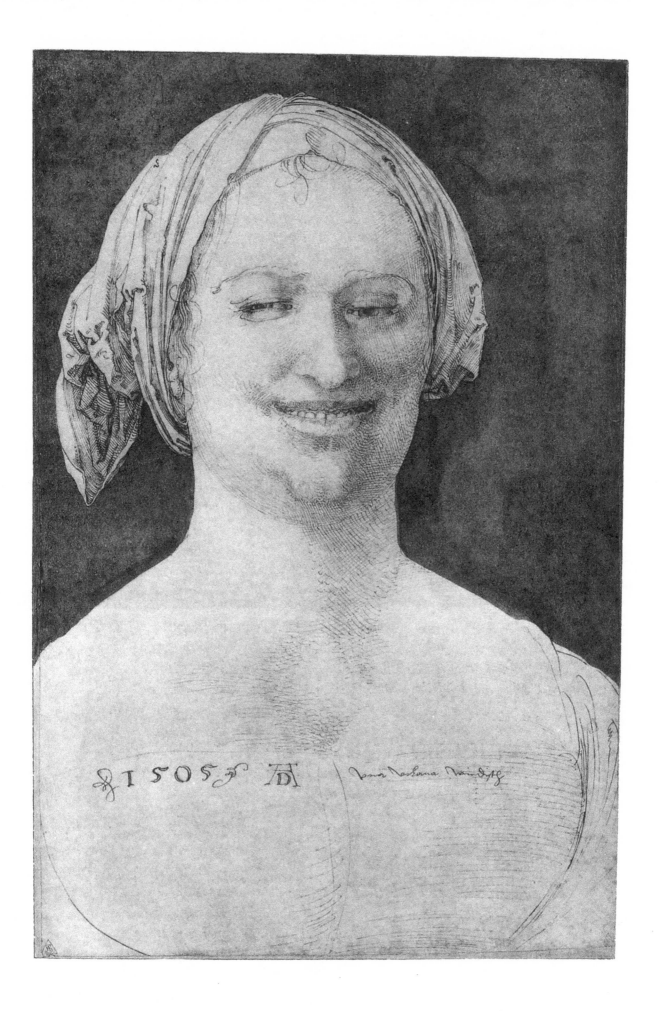

24 REAR VIEW OF A FEMALE NUDE HOLDING A CAP. 1506

Brush drawing on blue paper with white highlights. Kupferstichkabinett, Berlin. 283 × 224 mm; $11\frac{3}{16}$ × $8\frac{13}{16}$ in.

The experience of form is translated into splendid large-scale lines. This is a typical example of the broad "Italian" manner which replaces the delicate strokes of the previous years (compare the 1504 Eve). The shaded areas become less dense as they approach the outer contour of the forms. The background is dark down to the onset of the floor line.

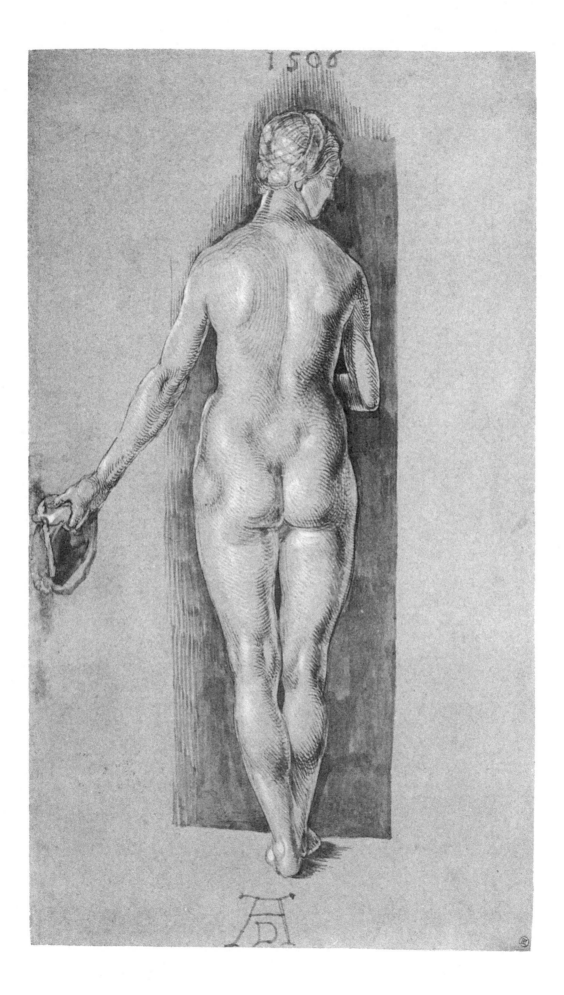

25 Seated nude child. 1506

Brush drawing on blue paper with white highlights. Kunsthalle, Bremen. 403 × 266 mm; $15\frac{7}{8}$ × $10\frac{1}{2}$ in.

This is a study for the Christ Child in the 1506 "Madonna with the Greenfinch" in Berlin. In the painting the movement, in connection with the motif of the bird, was essentially altered, the left arm being held horizontally and the leg below it drawn up. This Italianate putto has the characteristic flesh folds in the torso and the ankles. The relationship between the skull and the face, and the strong bulges at the temples, are reminiscent of Leonardo. The firm gaze of the eyes is another new feature. The left elbow shows a pentimento.

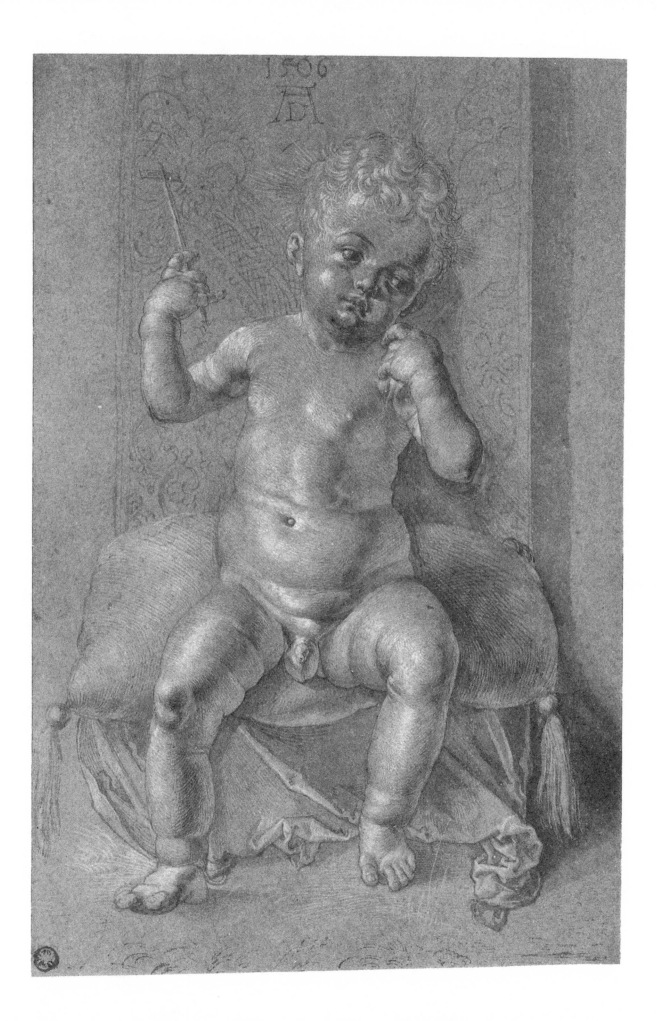

26 THE ARCHITECT HIERONYMUS OF AUGSBURG. 1506

Brush drawing with white highlights on a blue ground. Kupferstichkabinett, Berlin. 386 × 262 mm; $15\frac{3}{16} \times 10\frac{5}{16}$ in.

The sitter was a builder of the German merchants' house in Venice and appears, in this same view, in the painting " The Feast of Rose Garlands," which the German community in Venice had commissioned from Dürer.

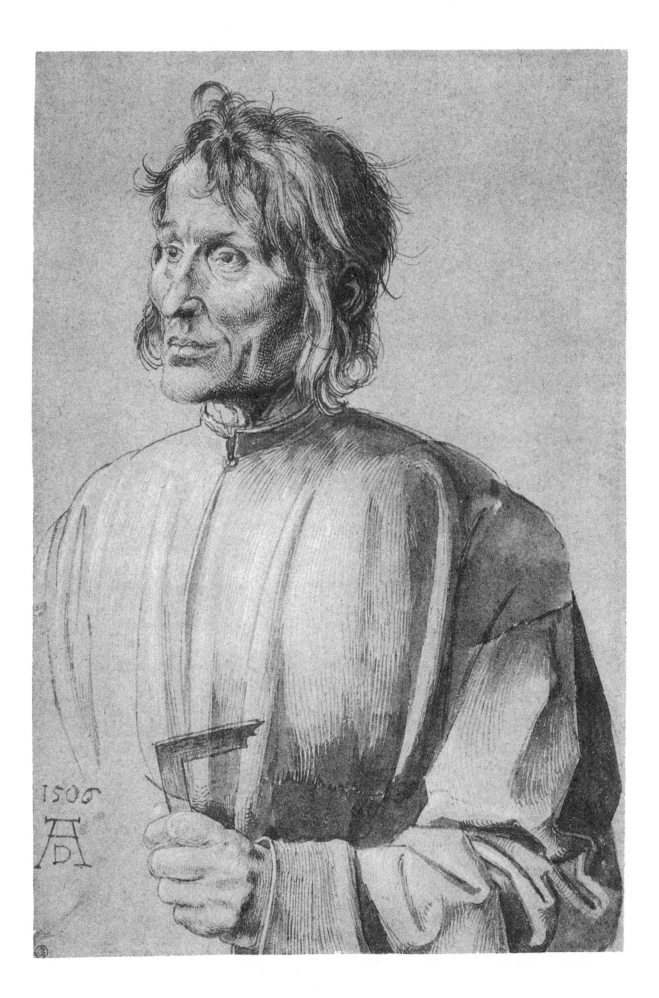

27 BOY'S HANDS. 1506

Brush drawing on blue paper with white highlights. Blasius Collection, Braunschweig. 206 × 185 mm; $8\frac{1}{8}$ × $7\frac{5}{16}$ in.

This is a study for the painting "The Young Christ Arguing with the Doctors" in the Galleria Barberini, Rome. The right index finger touches the left thumb in a counting-out gesture. The line work is gnarled and un-Venetian, but the drawing as a whole is delicately Italian in feeling, broad and colorful in execution.

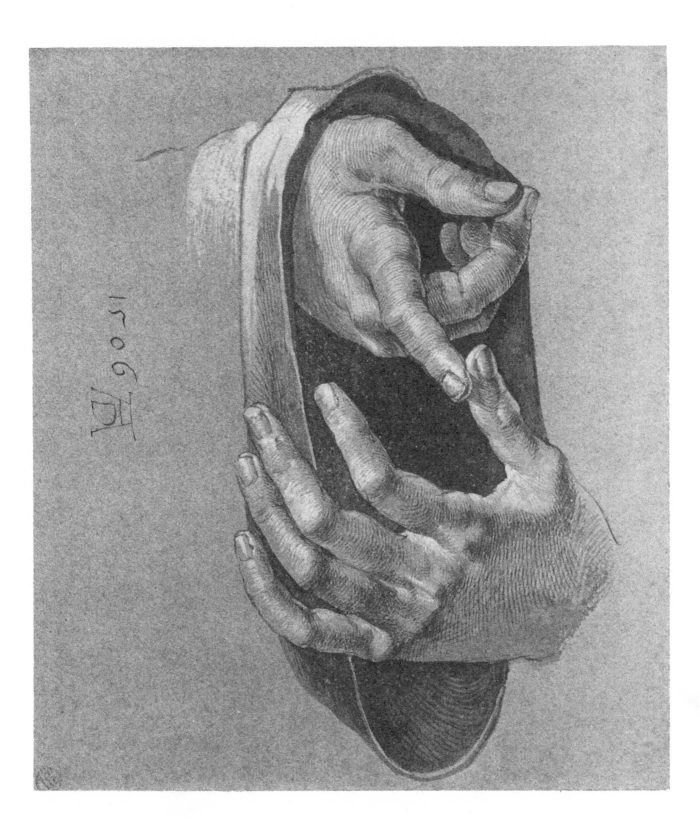

28 STUDY OF DRAPERY. 1508

Brush drawing on a dark ground with white highlights. Kupferstichkabinett, Berlin. 400 × 235 mm; $15\frac{3}{4}$ × $9\frac{1}{4}$ in.

This drawing, a study for the figure of St. Paul in the " Heller Altar," is a primary example of the monumental drapery of the middle period. The contrast with Grünewald should be borne in mind: in Dürer, the light and shade are entirely subservient to the plastic form; in Grünewald, they create a general, unseizable movement that extends beyond the surfaces and blends the figure into the background.

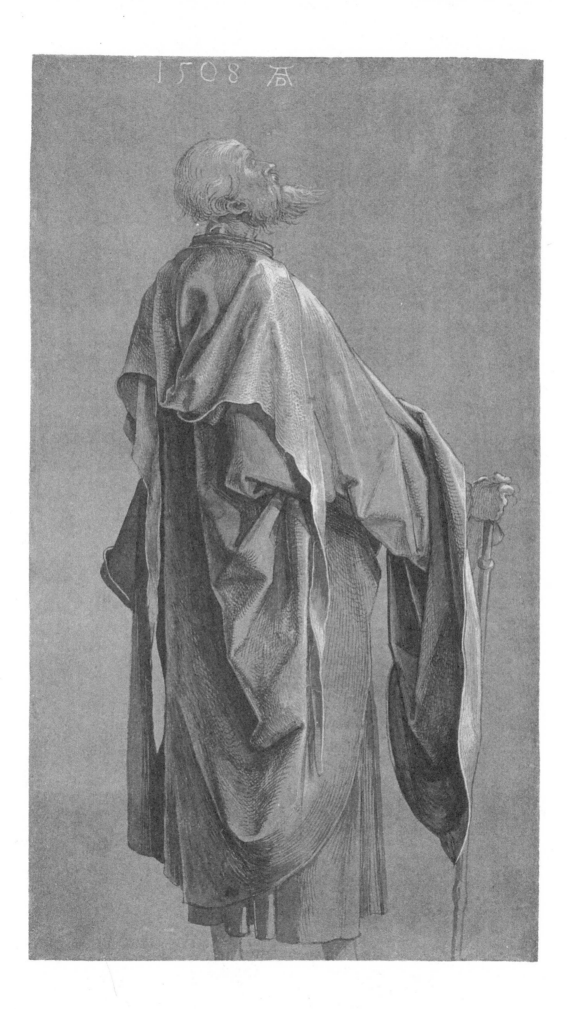

29 MALE NUDE, HALF LENGTH. 1508

Brush drawing with white highlights on dark paper. Kunsthalle, Bremen.
198 × 216 mm; 7$\frac{13}{16}$ × 8$\frac{1}{2}$ in.

Study for the Christ in the " Heller Altar."

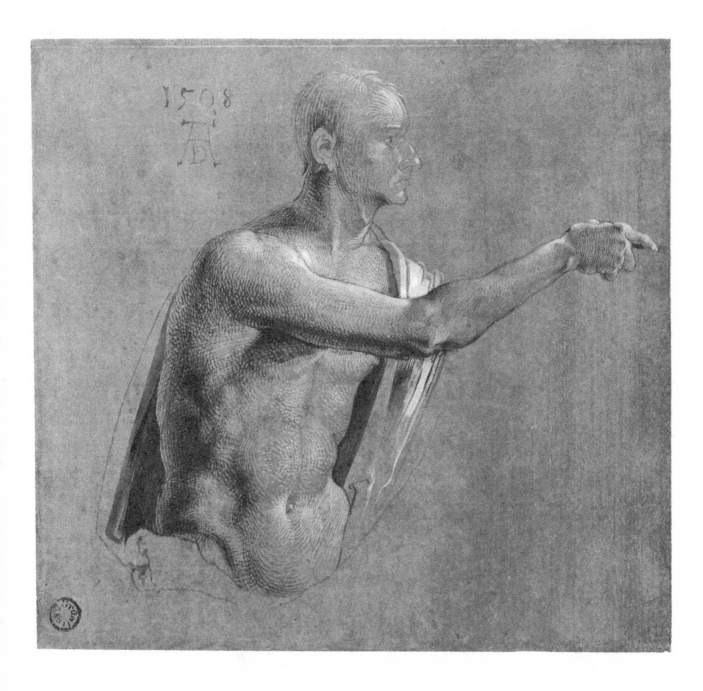

30 STUDY OF DRAPERY. 1508

Brush drawing on dark paper with white highlights. Louvre, Paris.
257 × 192 mm; 10⅛ × 7$\frac{9}{16}$ in.

Study for the Christ in the "Coronation of the Virgin" section of the "Heller Altar."

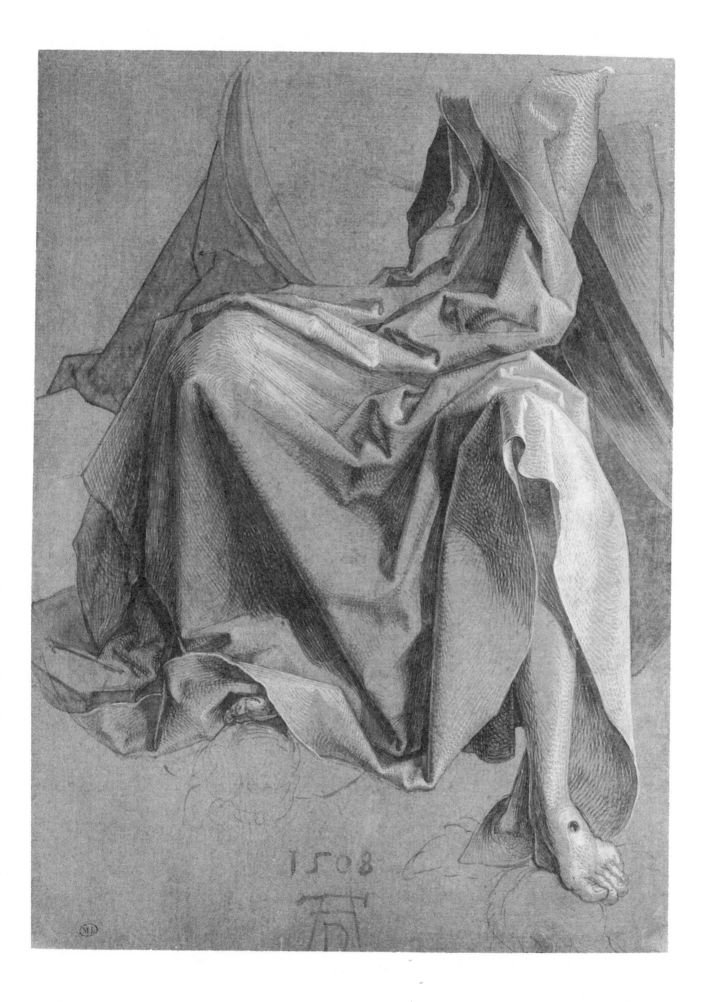

31 HEAD OF AN APOSTLE LOOKING DOWNWARD. 1508
Brush drawing with white highlights on a dark ground. Albertina, Vienna.
316 × 229 mm; $12\frac{7}{16}$ × 9 in.

*Study for the "Heller Altar." This was a type that long interested Dürer and is
still discernible in the head of St. Paul in the Munich paintings of
"Apostles." All the forms contribute with unusual power to the unified
expression.*

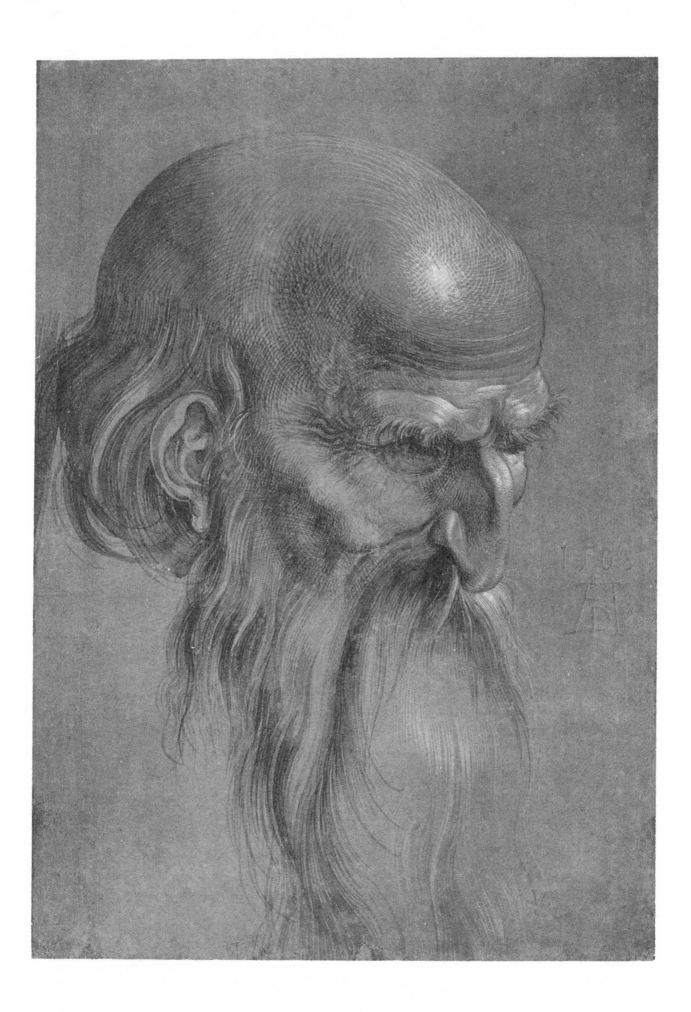

32 HEAD OF AN APOSTLE LOOKING UPWARD. 1508

Brush drawing with white highlights on a dark ground. Kupferstichkabinett, Berlin. 288 × 207 mm; $11\frac{5}{16} \times 8\frac{3}{16}$ in.

Study for the "Heller Altar." The modern mistrust of any calligraphy in drawing should not be allowed to blind the viewer to the new psychological greatness that such figures introduce into German art.

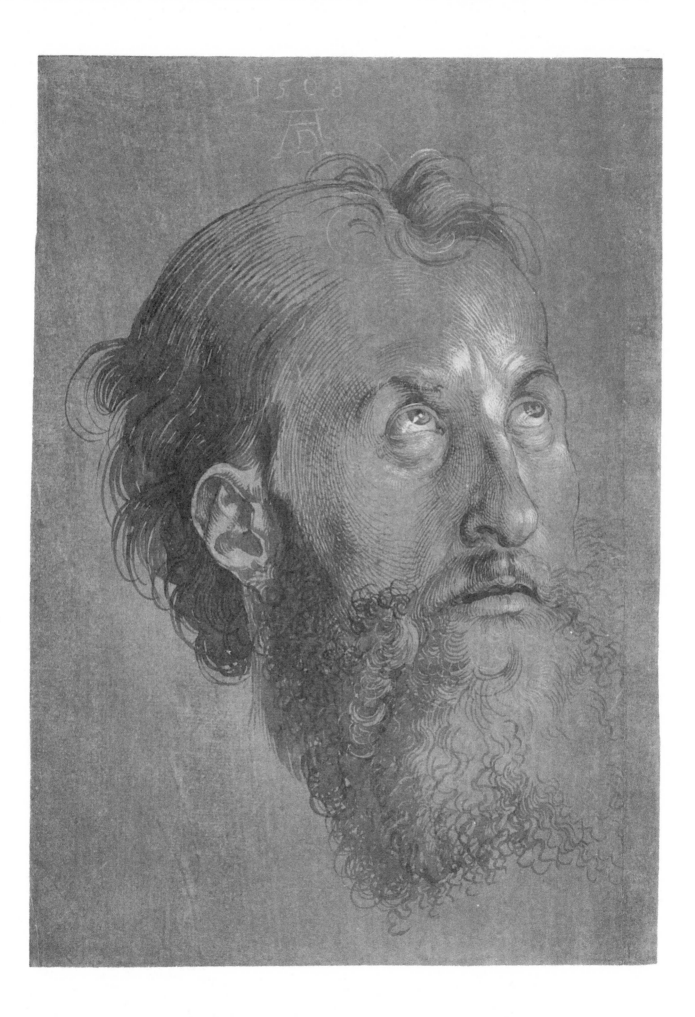

33 MAN'S HANDS JOINED IN PRAYER. 1508
Brush drawing with white highlights on a dark ground. Albertina, Vienna.
290 × 197 mm; $11\frac{7}{16}$ × $7\frac{3}{4}$ in.

Study for the "Heller Altar."

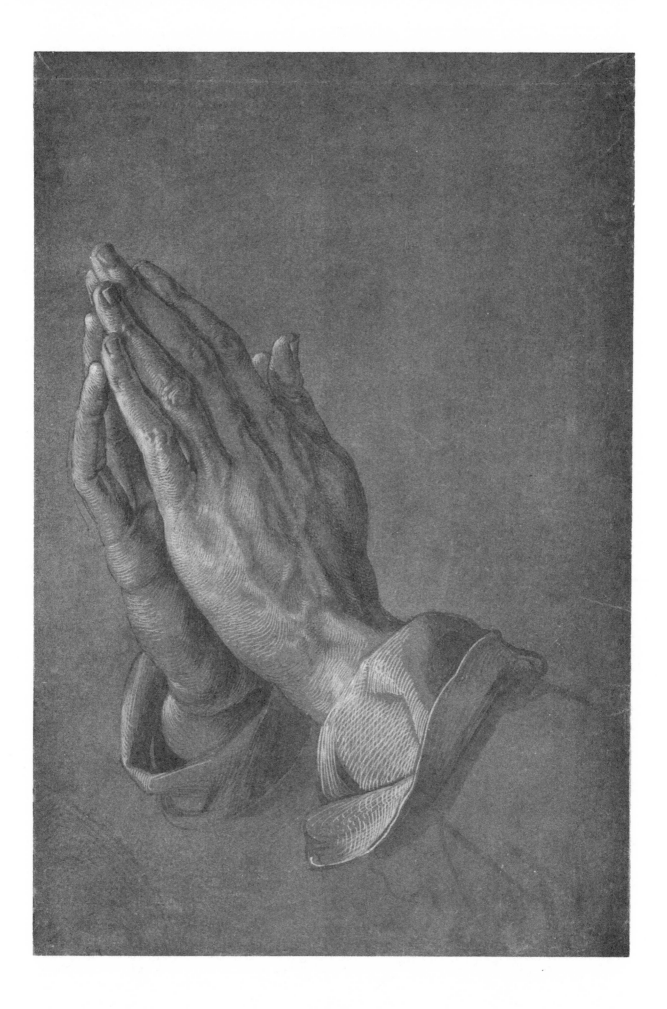

34 FEET OF A KNEELING MAN. 1508

Brush drawing on a dark ground with white highlights. Most recently in the collection of the Comtesse Béhague, Paris. 177 × 217 mm; 7 × $8\frac{9}{16}$ in.

Study for the St. Peter in the "Heller Altar." To feel the distinctive quality of the conception of form, it is necessary to compare the treatment of an analogous problem in Italian art, for example in Mantegna: whereas the Italian eye does not sacrifice the connection of the foot with the leg, here the bulbous, rootlike forms have a life of their own and join in a miraculous unity.

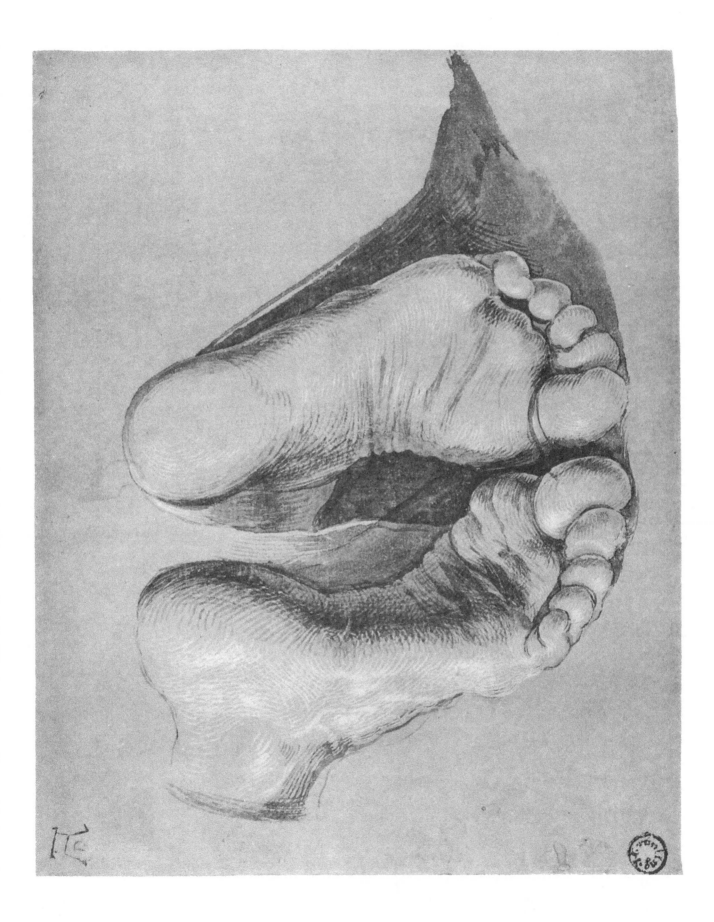

35 LUCRECE. 1508

Brush drawing with white highlights on a dark ground. Albertina, Vienna. 422 × 226 mm; 16⅝ × 8⅞ in.

This drawing is important, since it is the basis for the Munich painting "Lucrece" done ten years later (1518). In addition to the alteration in the right arm and the different execution of the loincloth in the painting, there is also a broadening—not by Dürer—of the drapery over the abdomen.

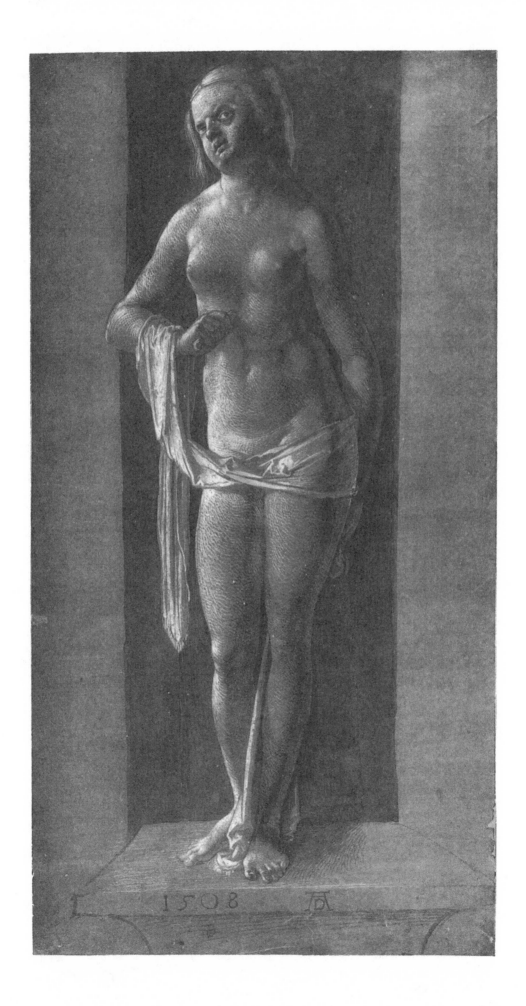

36 HEAD OF A NEGRO. 1508

Charcoal. Albertina, Vienna. 320 × 218 mm; 12$\frac{5}{8}$ × 8$\frac{9}{16}$ in.

This study was done in Nuremberg. A Negro always figured in scenes of the Adoration of the Wise Men. This drawing is parallel in time with the studies for the "Heller Altar"; in comparison with them it has a special freshness.

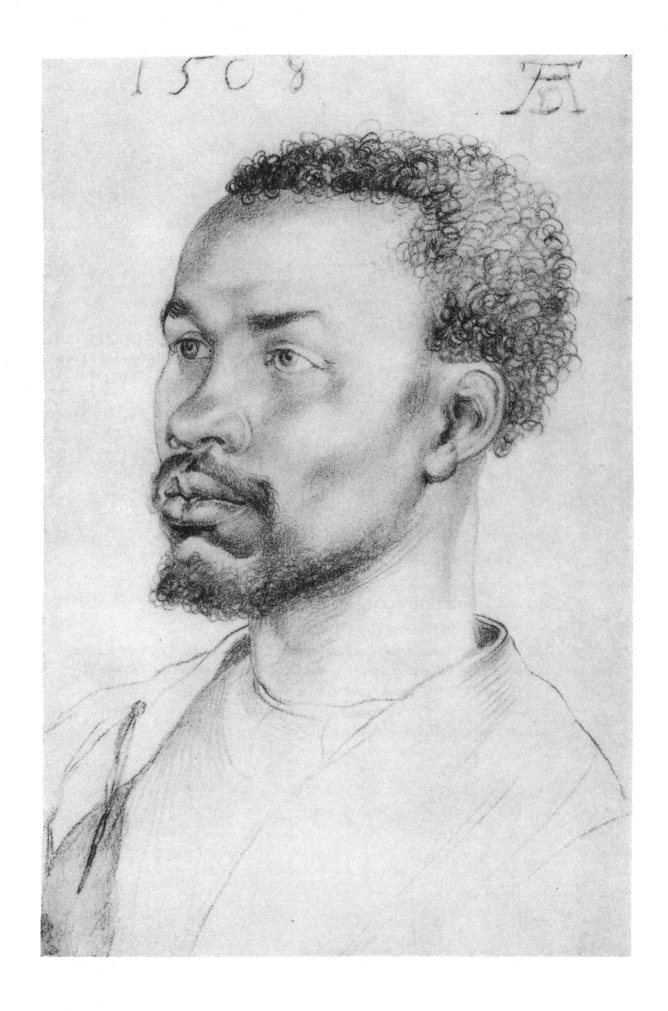

37 THE LAMENTATION. 1513? (the last digit is illegible)

Charcoal. Kunsthalle, Bremen. 414 × 292 mm; 16¼ × 11½ in.

The drawing is somewhat damaged and retouched by another hand. I consider it a sketch for a painting. It is an important example of pure foreground composition with motifs of strong foreshortening. The steps leading inward are indispensable in preparing the eye for the foreshortening of Christ's legs. (Compare the earlier Lamentations in Munich and Nuremberg.)

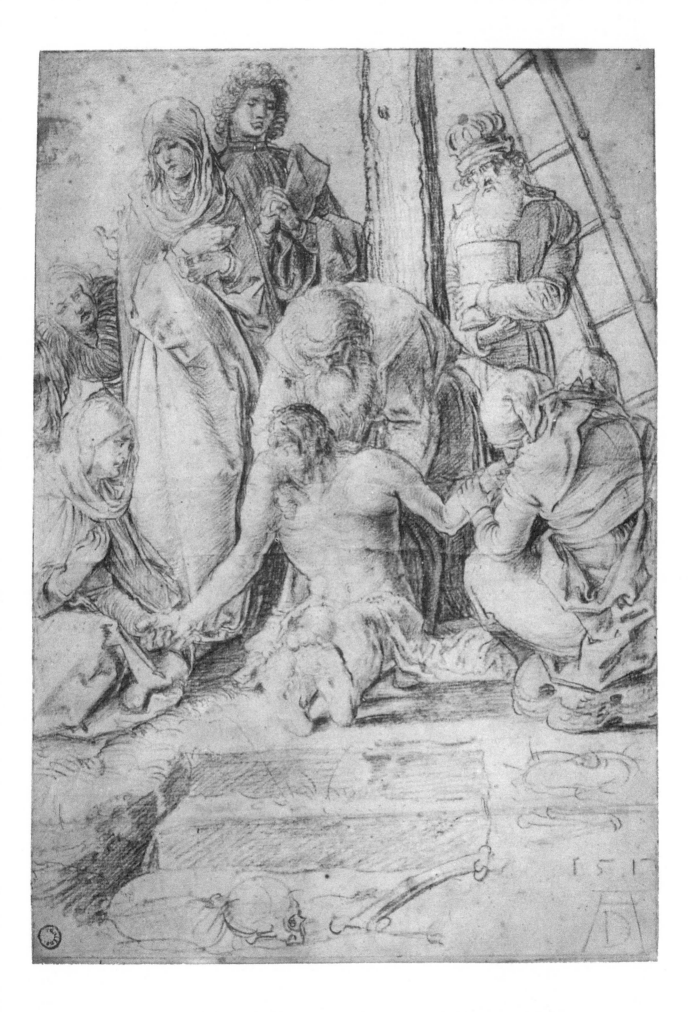

38 THE VIRGIN NURSING THE CHILD. 1512

Charcoal. Albertina, Vienna. 418 × 288 mm; $16\frac{7}{16}$ × $11\frac{5}{16}$ in.

(The sheet is drastically cut at the right and the bottom.) This can scarcely be considered as a preliminary study for a painting; on the contrary, it is an independent drawing par excellence, *with a great deal of curly and distinct linear movement. It is clear from this how incompletely the tortured motif of the 1512 painting of the Virgin (Vienna) reveals the artist's general frame of mind in this period.*

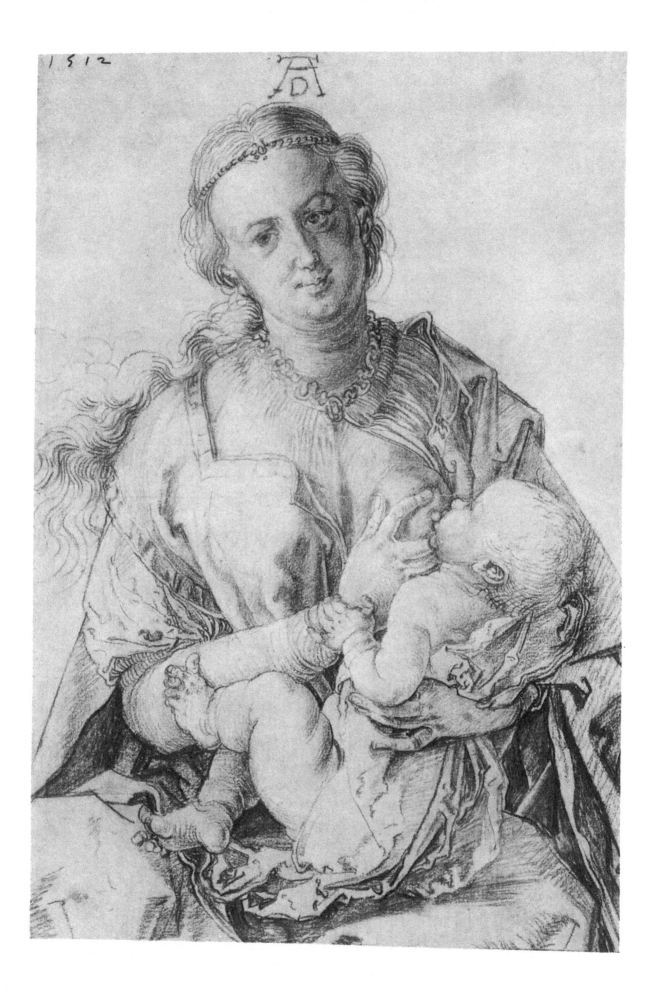

39 DÜRER'S MOTHER. 1514 ("an Oculi" = March 19)

Charcoal. Kupferstichkabinett, Berlin. 421 × 303 mm; $16\frac{9}{16}$ × $11\frac{7}{8}$ in.

The legend reads: "Dz ist albrecht dürers muter dy was alt 63 Jor" (This is Albrecht Dürer's mother when she was 63), with the addition: "vnd ist verschiden Im 1514 Jor am erchtag vor der crewtzwochn vm zwey genacht [gegen Nacht?]" (and died in 1514 on the Tuesday before Rogation Week [= May 16] at two o'clock [in the afternoon?]). This drawing is unique in its power of spiritual expression. Ugliness is elevated to greatness. An important element is the kerchief, which, laid back over the left shoulder, accompanies the silhouette on the right side in a very simple line, while it breaks at right angles at the temple.

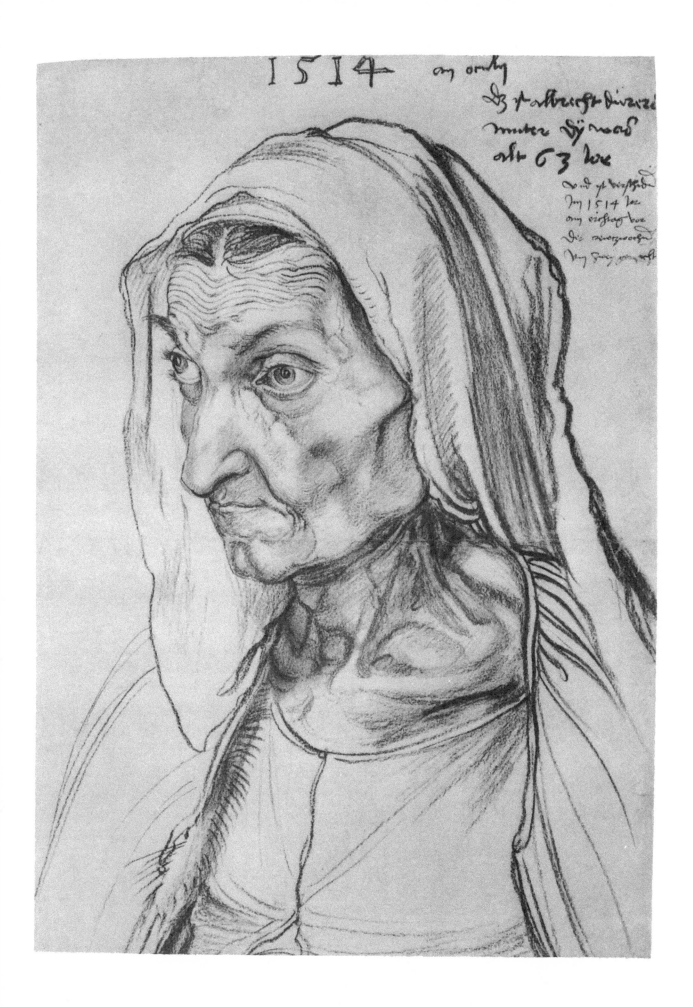

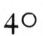 PORTRAIT OF A GIRL. 1515
Charcoal. Kupferstichkabinett, Berlin. 420 × 290 mm; 16½ × 11⅜ in.

It has been conjectured that the girl, whose eyes are not open equally wide and who has a somewhat sleepy expression, was a relative of Dürer's wife.

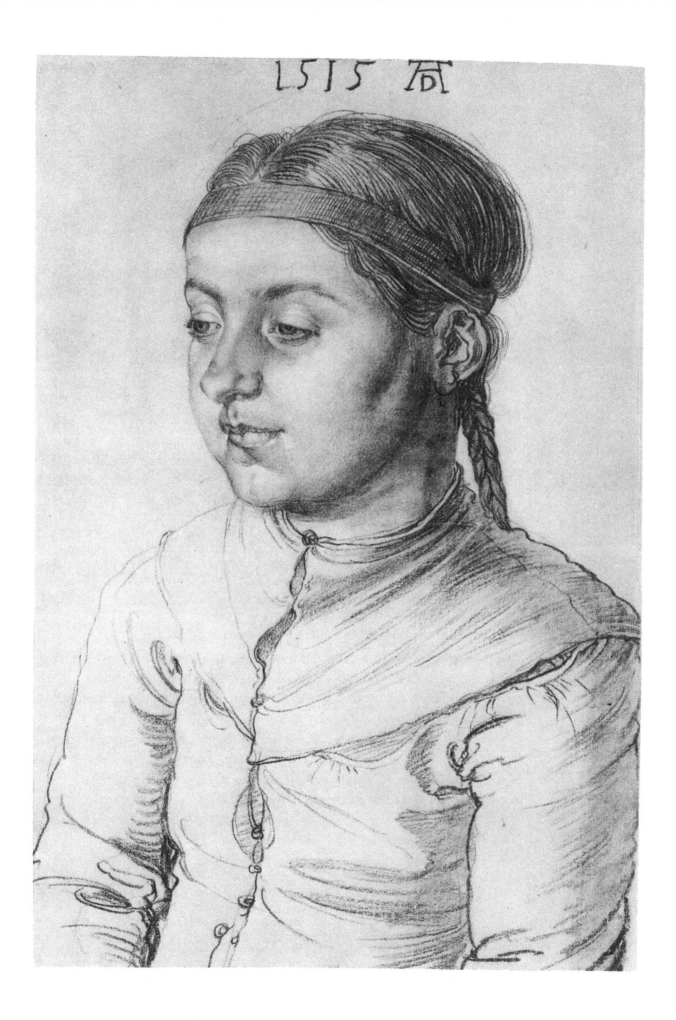

4 1 EMPEROR MAXIMILIAN I. 1518

Charcoal. Albertina, Vienna. 381 × 319 mm; 15 × 12½ in.

(The drawing has suffered: the color added to the face by another hand is now washed out, but has left behind large disfiguring traces.) The legend reads: "Das ist keiser maximilian den hab ich albrecht dürer zw awgspurg hoch obn awff der pfaltz in seine[m] kleinen stüble künterfett do man czalt 1518 am mandag noch Johannis tawffer" (This is Emperor Maximilian; I, Albrecht Dürer, drew his portrait at Augsburg, high up in the palace in his little cabinet in 1518 on the Monday after St. John the Baptist's Day). This is a preliminary study for the paintings in Vienna and Nuremberg and the (4) woodcuts B.153 and 154.

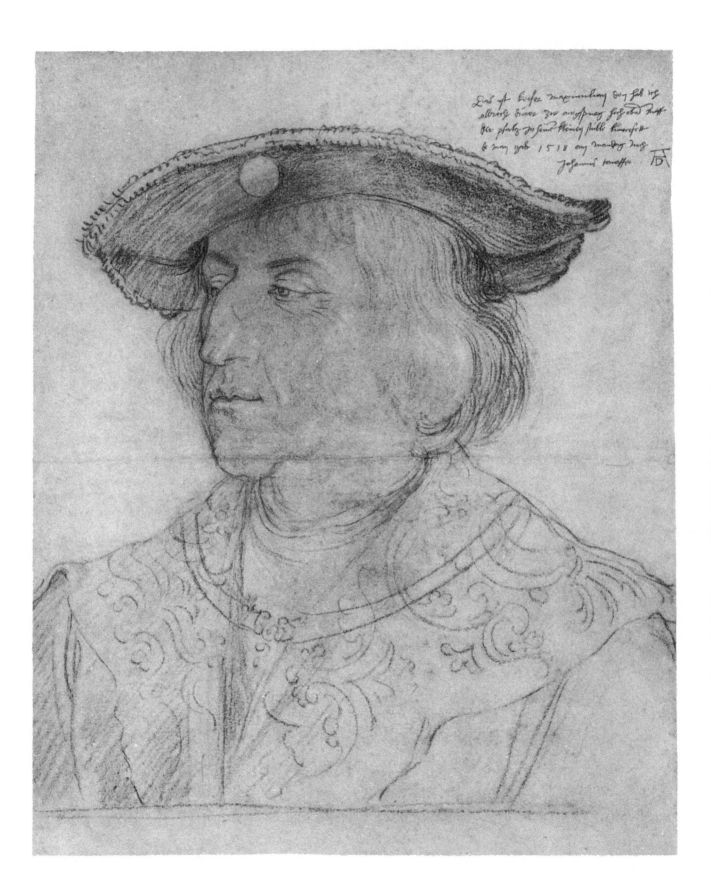

42 VIEW OF HEROLDSBERG. 1510

Pen. Musée Bonnat, Bayonne. 211 × 263 mm; $8\frac{5}{16}$ × $10\frac{5}{16}$ in.

The village, identified by Mitius as the model for the drawing, is 12 km north of Nuremberg. The foreground has strong motifs that draw the eye back into the picture. The lines of the roofs lead inward. Halfway up the left edge there is a circle, and in reference to it there is a legend (near the steeple) which is now very hard to make out: "hab acht awffs awg" (be careful with the eye, i.e., with the perspective construction)—is this legend Dürer's?

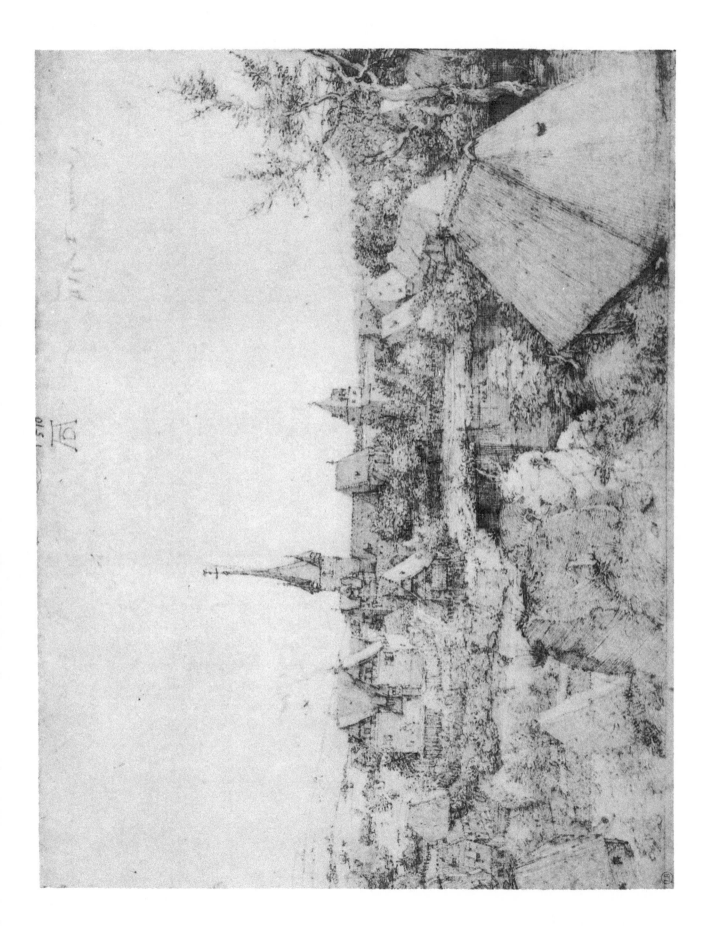

43 THE HOLY FAMILY IN A ROOM.

Pen. Blasius Collection, Braunschweig. 254 × 216 mm; 10 × 8½ in.

This is a hasty sketch of a motif that is otherwise strangely absent from Dürer's production: the closed dwelling room with the figures of the Mother, Child and Foster Father. The Virgin is seated on the edge of the bed, in front of which is a chest and at the foot of which is the cradle. In the background St. Joseph is reading at a table. In comparison with the earlier series "The Life of the Virgin," in which reality and irreality intermingle, the tone here is more that of pure depiction of actuality. The pictorial image is simplified in the classic way, by sweeping horizontal and vertical lines.

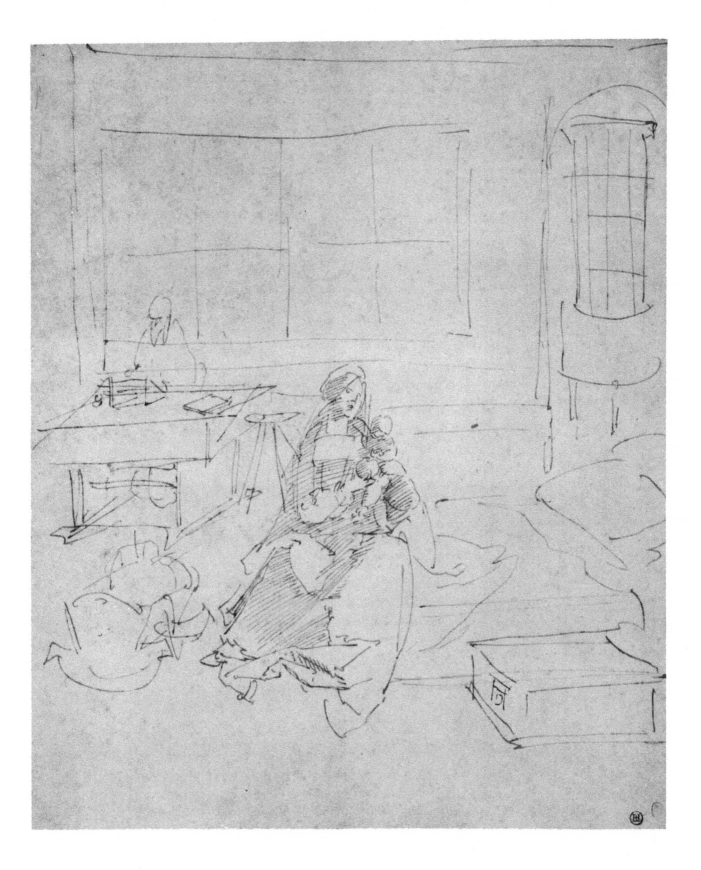

44 THE MADONNA AND CHILD ON A GRASSY BANK. 1511
Pen. Louvre, Paris. 203 × 154 mm; 8 × $6\frac{1}{16}$ in.

The pen work is curiously light and piquant. The movement of planes in the figure is continued in the cliff in the background. Although this drawing cannot be considered a plein-air *work, it nevertheless has an effect of sunniness.*

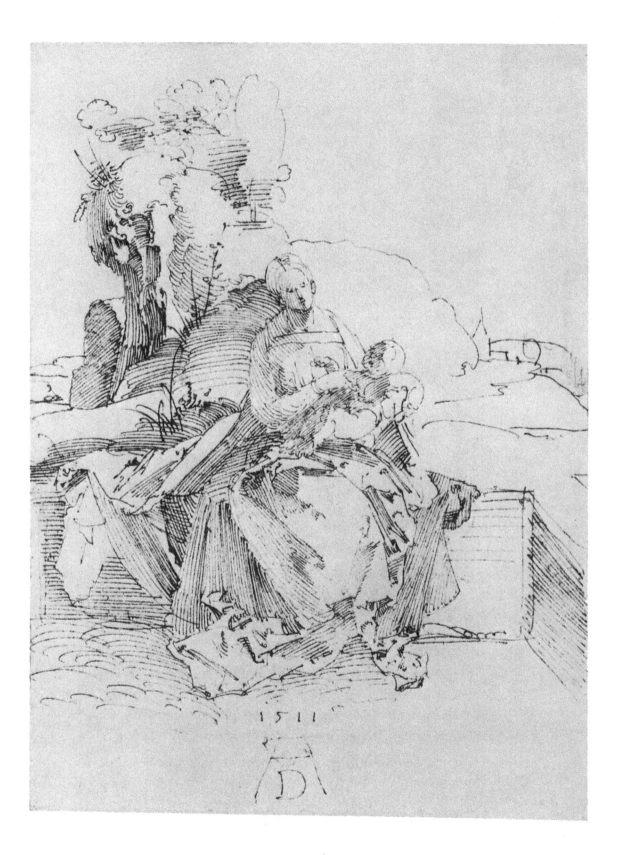

45 THE DEATH OF THE VIRGIN. 1508/1510
Pen. Albertina, Vienna. 300 × 219 mm; $11\frac{13}{16}$ × $8\frac{5}{8}$ in.

This is a preliminary drawing for the woodcut in " The Life of the Virgin,"
dated 1510, which exhibits several improvements in the composition, in the
direction of a firmer grouping of the figures and the working out of strong
leading lines (for example, the bed curtain is raised obliquely on one side to
match the movement of St. John, who is handing the taper to the dying Virgin).
The calculation of tones was also somewhat modified. It is extremely interesting
to observe in detail the extent to which the linear material of the woodcut is
already anticipated in the drawing. The number of extant preliminary drawings
for Dürer prints is quite small: an unusual amount must have been lost.

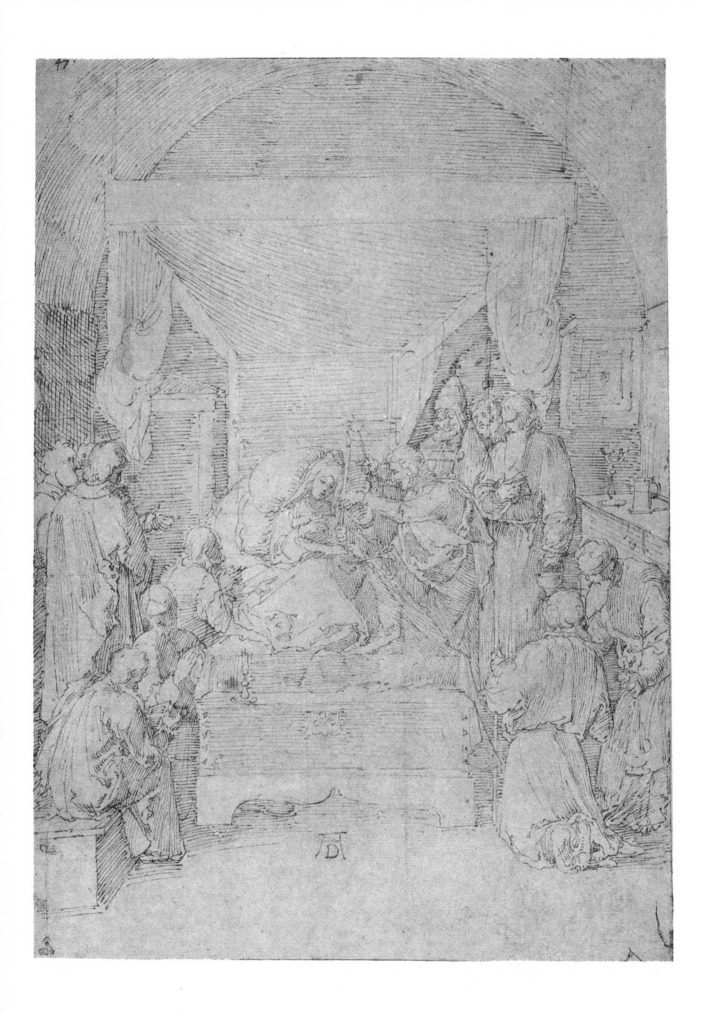

46 ST. JEROME IN HIS STUDY. 1511

Pen. Biblioteca Ambrosiana, Milan. 190 × 151 mm; $7\frac{1}{2}$ × $5\frac{15}{16}$ in.

Preliminary study for the woodcut B.114, in which the composition is further simplified and compressed, a large white curtain of diagonal contour playing a decisive role in the change.

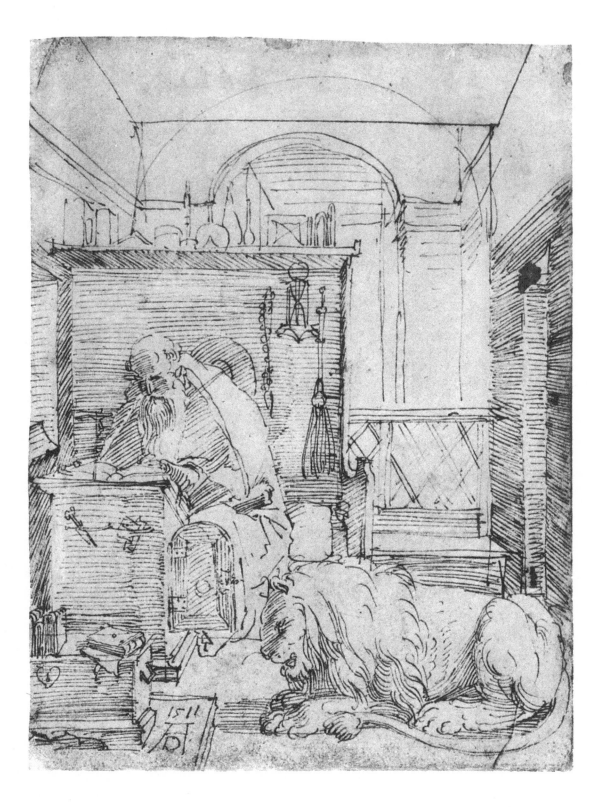

47 THE NATIVITY: ADORATION OF THE CHRIST CHILD IN THE STABLES WITH THE VIRGIN AND ST. JOSEPH. 1514

Pen. Albertina, Vienna. 313 × 217 mm; $12\frac{5}{16}$ × $8\frac{9}{16}$ in.

This is a composition of rare ardor. The warmth of the feeling is guaranteed by the date 1514: the year of the " Melancholy " and the " St. Jerome." It is possible that this drawing was conceived as a woodcut; then it would have become a worthy counterpart to those copperplate engravings. In comparison with the 1511 woodcut " The Adoration of the Wise Men," we already find here a characteristic simplification of the architecture and a tighter relationship between the figures and the architectural accompaniment. There are simple walls in the background and a calm closed plank ceiling; the effect is one of large-scale tone contrasts.

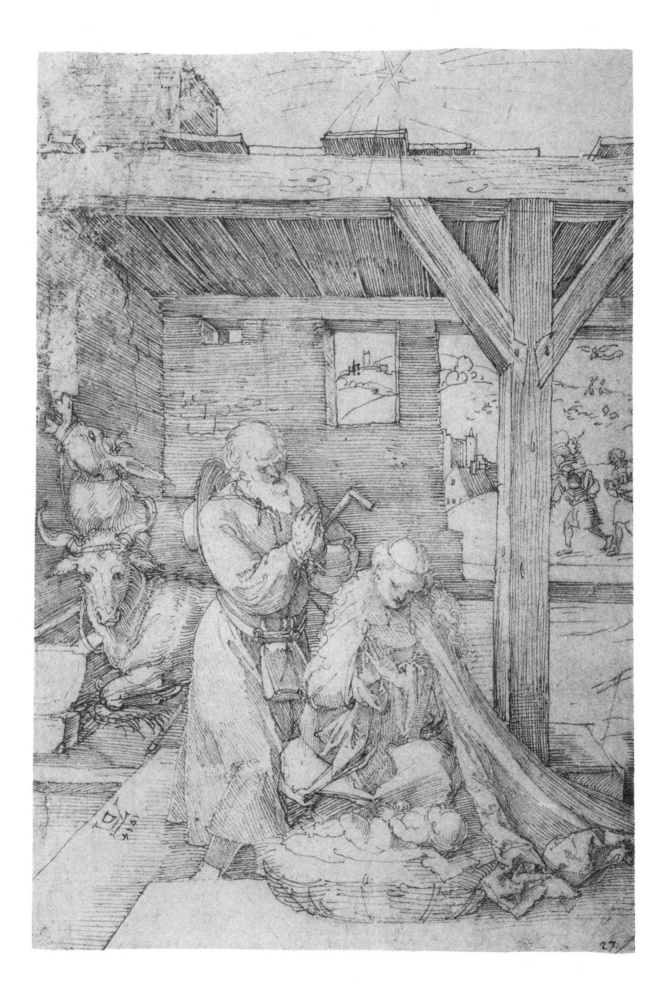

27

48 SEATED WOMAN. 1514

Pen. Kupferstichkabinett, Berlin. 217 × 162 mm; $8\frac{9}{16}$ × $6\frac{3}{8}$ in.

This is a drawing from a model. H. S. Beham later handled such figures in woodcut style. Dürer's genre pieces are copperplate engravings, but this drawing was not so used.

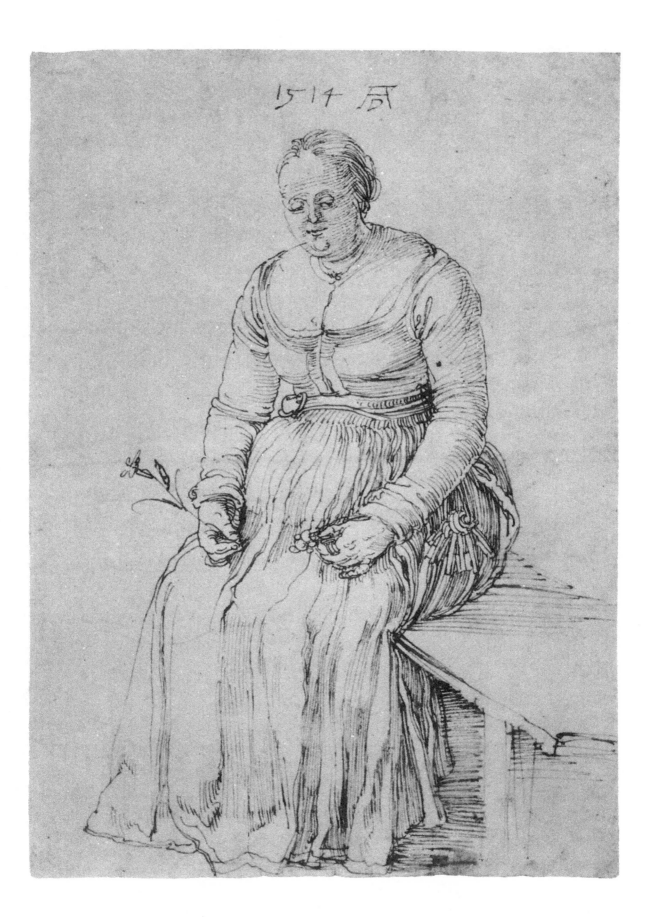

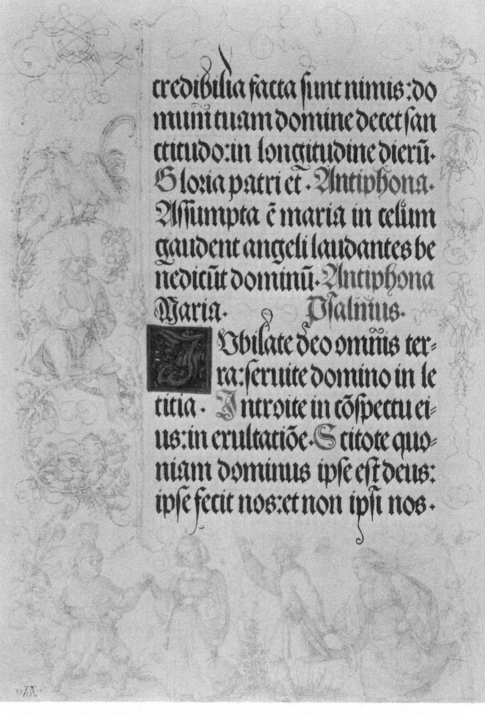

49

PAGES OF MARGINAL DRAWINGS FOR EMPEROR MAXIMILIAN'S PRAYER
BOOK. 1515

Pen with ink of different colors. Staatsbibliothek, Munich.
277 × 188 mm; 10⅞ × 7⅜ in.

*Giehlow's research has made it more than probable that the drawings were to be
translated into the woodcut medium and that in that form the "Prayer Book"*

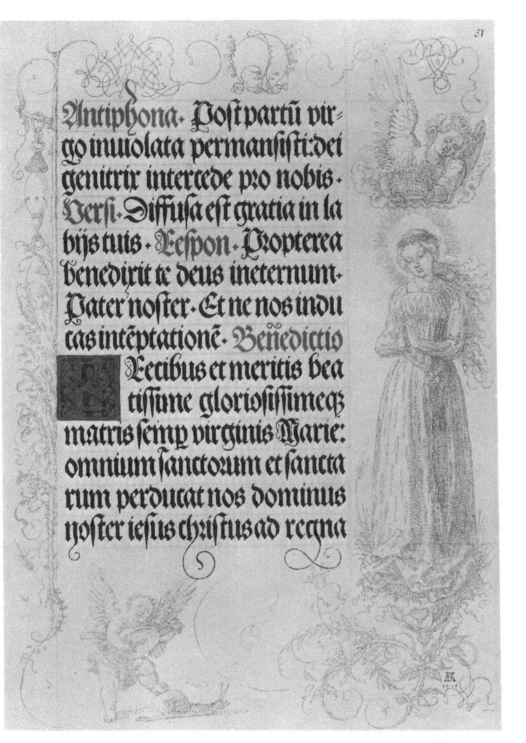

50

was intended for the Knights of St. George. The spirit in which Dürer handled
his assignment is characteristically exhibited in the (intentionally humorous)
figures which—on the page illustrated opposite—accompany the text of Psalm 100,
"Jubilate deo omnis terra. Servite domino in letitia . . ." (Make a joyful noise
unto the Lord, all ye lands. Serve the Lord with gladness . . .). Plate 50 is
another page from the "Prayer Book."

5 1 DESIGN FOR A GOBLET, WITH A VARIANT OF THE BASE. Done in the mid-1510's

Pen. British Museum, London. 256 × 167 mm; $10\frac{1}{16} \times 6\frac{9}{16}$ in.

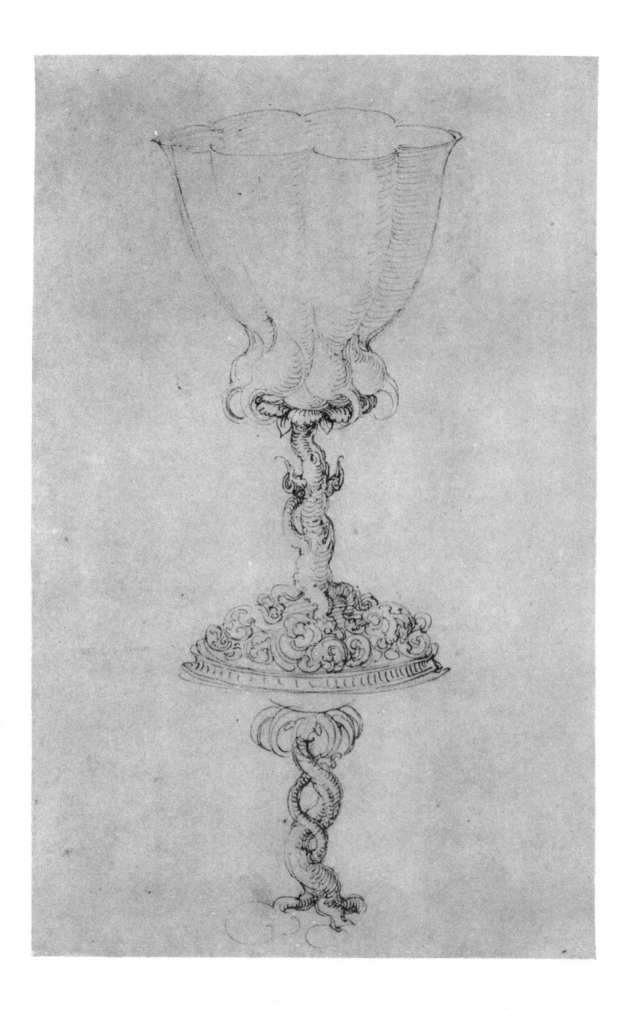

5 2 SIX GOBLETS.

Pen. Bibliothek, Dresden. 200 × 285 mm; $7\frac{7}{8}$ × $11\frac{3}{16}$ in.

(Bruck, "Das Dresdner Skizzenbuch," Plate 156.) The legend reads: "morgen will ich ir mer machn" (tomorrow I shall make more of them). Individual Italian motifs are mingled with the German late Gothic style.

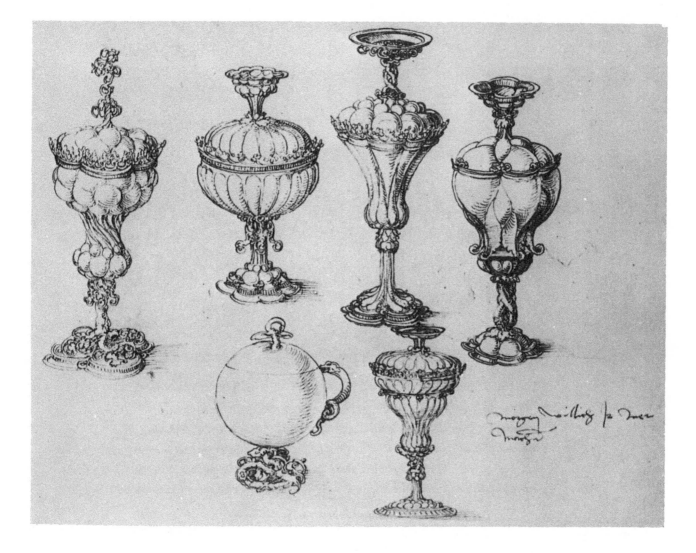

53 MALE AND FEMALE NUDES. 1516

Pen. Städelsches Kunstinstitut, Frankfurt. 258 × 225 mm; $10\frac{1}{8}$ × $8\frac{13}{16}$ in.

(The significance of the action has not yet been convincingly explained.) This is a drawing of great lightness with open, quite transparent patches of strokes. The line that characterizes the form is completely absorbed in ornamental beauty. In the background, behind the lower third of the height of the figures, there is an area of parallel horizontal lines—a feature that recurs elsewhere (compare the "Five Nudes" of 1526, Plate 77).

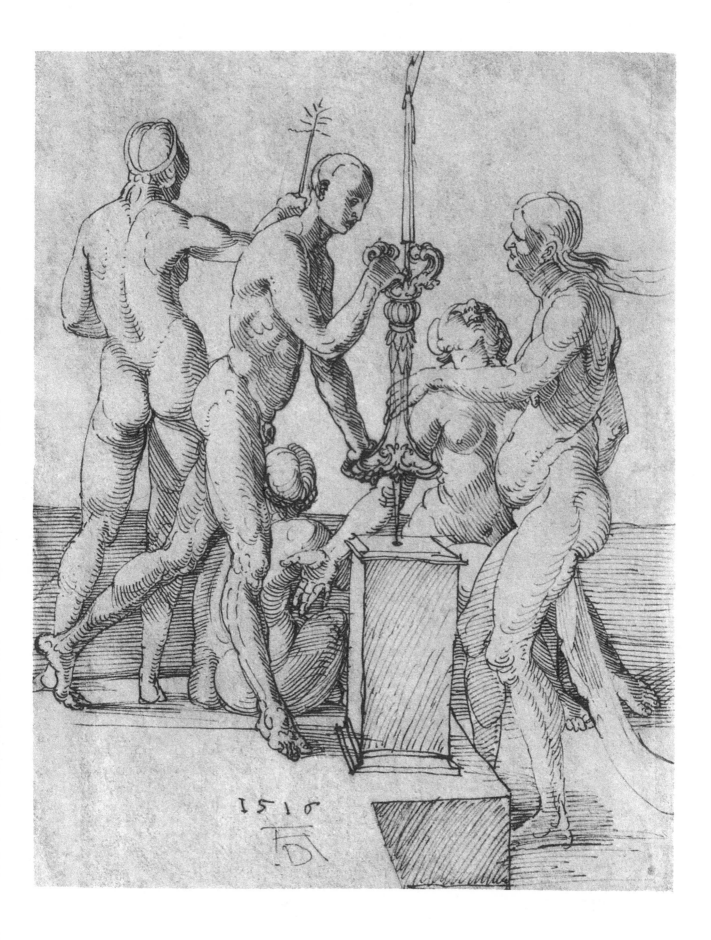

54 MALE AND FEMALE NUDES. 1515
Pen. Städelsches Kunstinstitut, Frankfurt. 271 × 212 mm; $10\frac{5}{8}$ × $8\frac{5}{16}$ in.
(*The meaning is not further known.*)

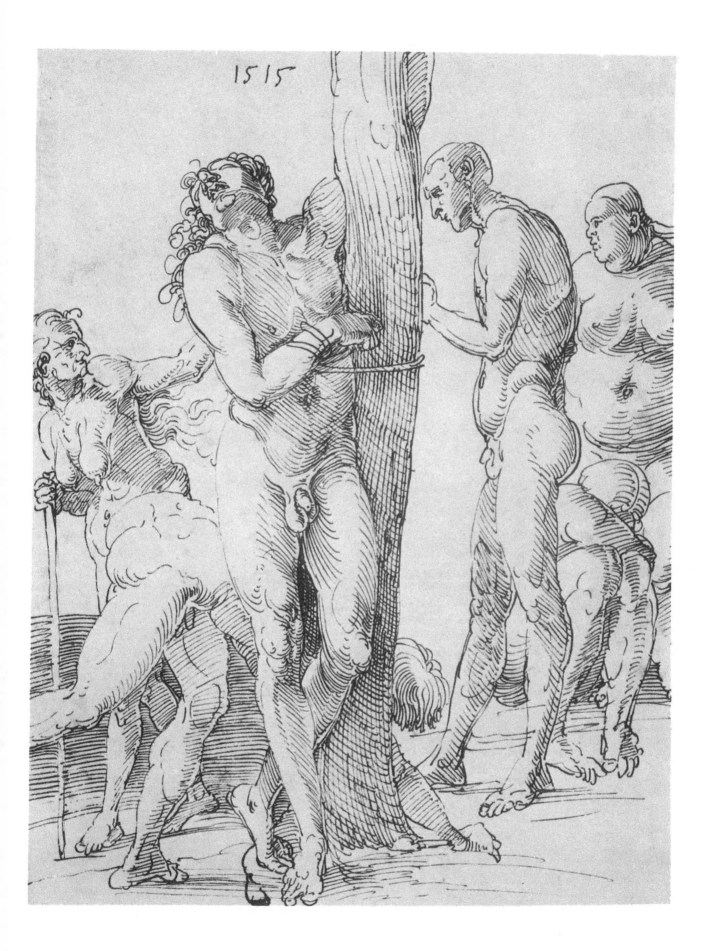

55 SEATED PROPHET. 1517

Pen. Albertina, Vienna. 232 × 192 mm; $9\frac{1}{8}$ × $7\frac{9}{16}$ in.

Seen from below, his hands hidden in his lap, the prophet is a significant conception in the solemn and splendid style of the late 1510's.

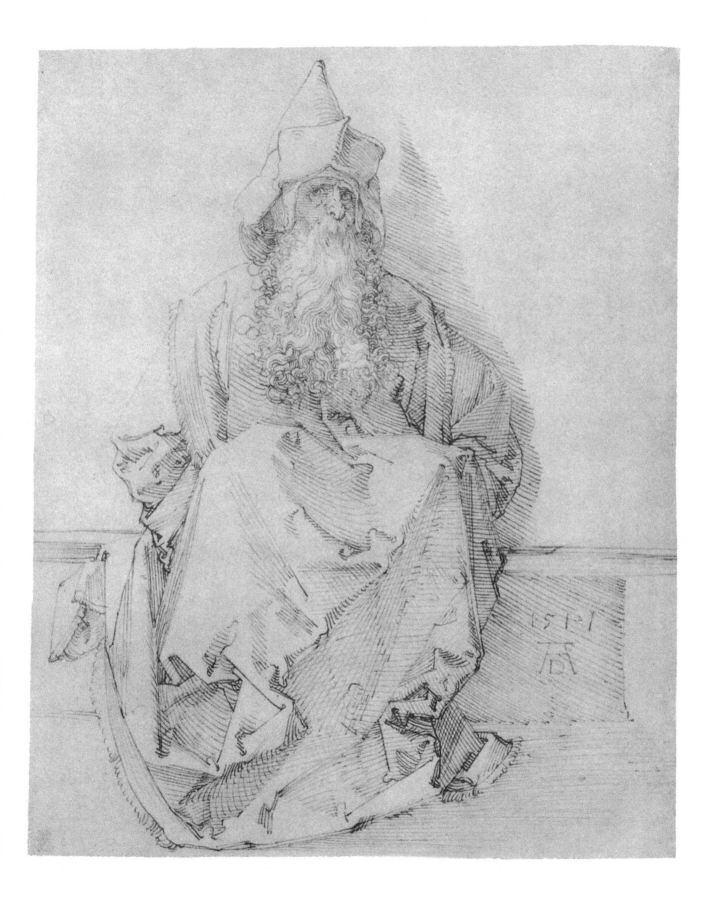

56 ST. JEROME IN HIS STUDY (WITHOUT CARDINAL'S ROBES)
CONTEMPLATING A SKULL.

Pen. Kupferstichkabinett, Berlin. 202 × 125 mm; $7\frac{15}{16}$ × $4\frac{15}{16}$ in.

The drawing dates from the second half of the 1510's. There are many straight
lines, with the strong horizontal and vertical architectural forms predominant.
The figure is placed within this system. Note the table with the simple right angles
formed by its parts—a feature that points toward Dürer's later style.

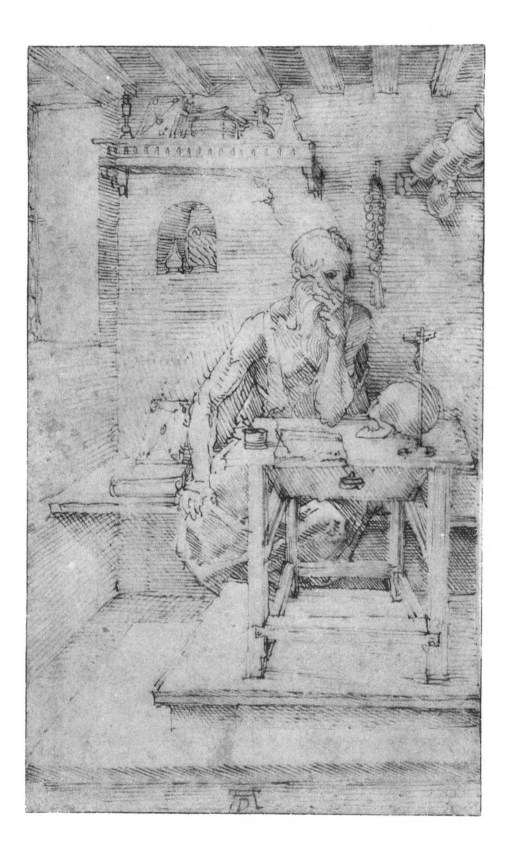

57 THE MADONNA AND CHILD WITH A MUSIC-MAKING ANGEL. 1519
Pen. Windsor Castle. 305 × 210 mm; 12 × 8¼ in.

There are only slight differences in tone, but an impression of richness is achieved by the very economical variation in direction of the areas of linear shading.

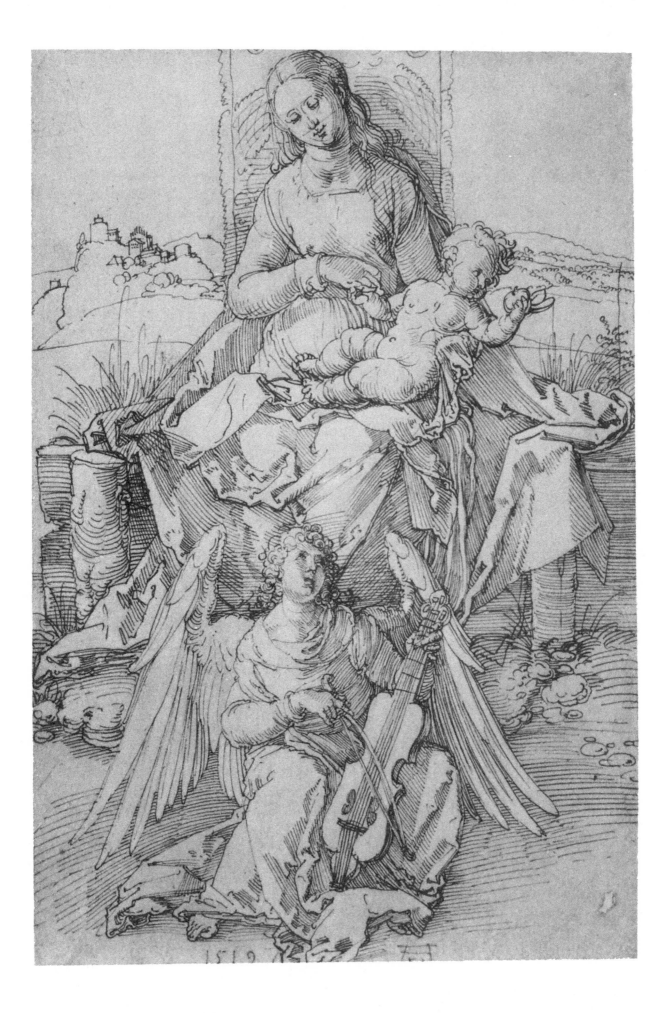

58 A YOUNG GIRL OF COLOGNE AND DÜRER'S WIFE. 1520
Silverpoint. Albertina, Vienna. 129 × 190 mm; $5\frac{1}{16}$ × $7\frac{1}{2}$ in.

This is a leaf from the sketchbook of the trip to the Lowlands. The legend reads: "awff dem rin mein Weib pey poparti" (on the Rhine, my wife at Boppard). Thus the drawing was made on the boat in July 1520. It gives the best (at least the best preserved) picture of Dürer's wife in her later years; with her cold protruding eyes and the domineering lines at the corners of her mouth, she does not look particularly lovable. Her juxtaposition with the young girl, whose coiffure is labeled "kölnisch gepend" (Cologne girl's headdress) by the artist, is certainly only accidental here, but is nevertheless not without analogies in the context of the sketches on this journey.

59 CASPAR STURM. 1520
Silverpoint. Musée Condé, Chantilly. 127 × 189 mm; 5 × $7\frac{7}{16}$ in.

This is a leaf from the sketchbook of the trip to the Lowlands. The legend reads: "1520 Caspar Sturm alt 45 Jor zw ach gemacht" (1520, Caspar Sturm, 45 years old, done at Aix-la-Chapelle [Aachen]). The lighting is peculiar, the landscape is related to the portrait. It is conjectured that the word "toll" indicates a tollhouse. The drawing is mentioned in the journal of the trip to the Lowlands (Lange-Fuhse 133, 17): "Ich hab den Sturm conterfet" (I did a portrait of Sturm).

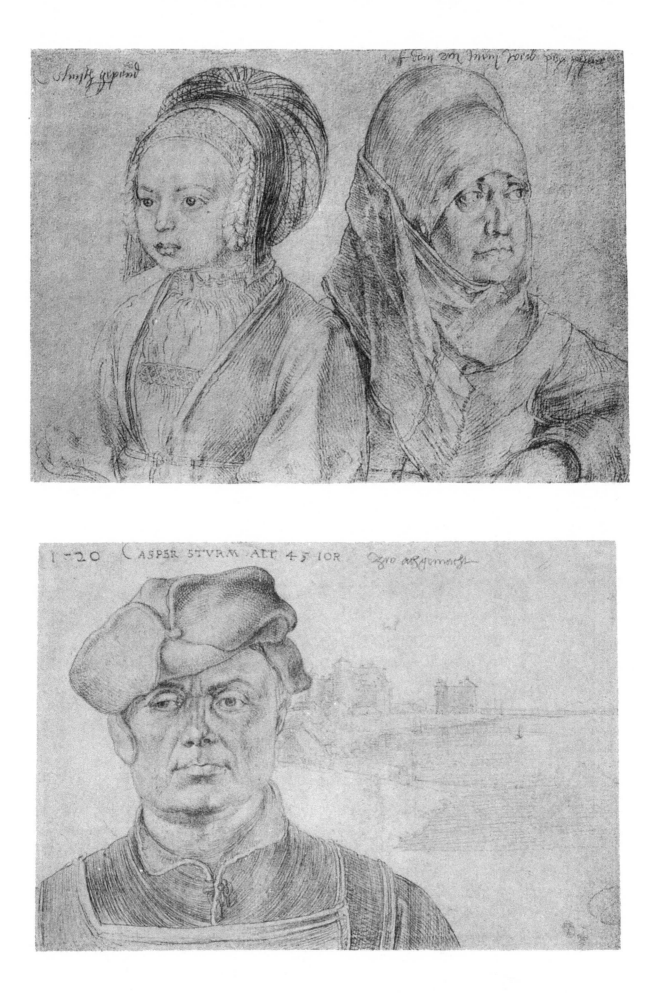

60 THE CATHEDRAL OF AIX-LA-CHAPELLE WITH ITS SURROUNDINGS, SEEN FROM THE CORONATION HALL. October 1520

Silverpoint. British Museum, London. 126 × 177 mm; $4\frac{15}{16}$ × $6\frac{15}{16}$ in.

This is a leaf from the sketchbook of the trip to the Lowlands. The legend reads: "zw ach das münstr" (the cathedral at Aix-la-Chapelle). The drawing is mentioned in the journal (Lange-Fuhse 133, 17) with the words: "Ich hab unser Frawen kirchen mit weiterm Umschweif conterfet" (I drew the Church of Our Lady with its environs). The octagonal palace chapel (center) still shows its thirteenth-century roof, which was later replaced by a dome. The Gothic tower of the western entrance hall is joined to the octagon by a bridge.

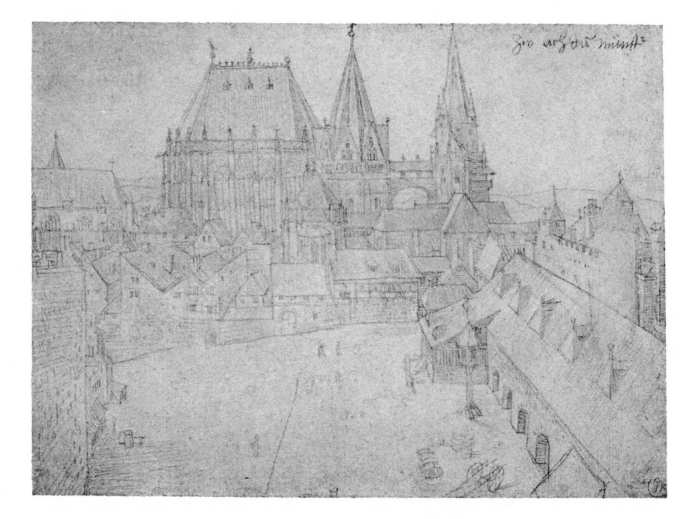

61 ANTWERP ("ANTORFF"). 1520

Pen. Albertina, Vienna. 213 × 283 mm; $8\frac{3}{8}$ × $11\frac{1}{8}$ in.

The waterfront is seen from an elevation; the pictorial technique is lively and bold. The reduction in the size of objects due to perspective, as seen in the ships, generates a vivid feeling of depth, all the more because the right foreground was never elaborated.

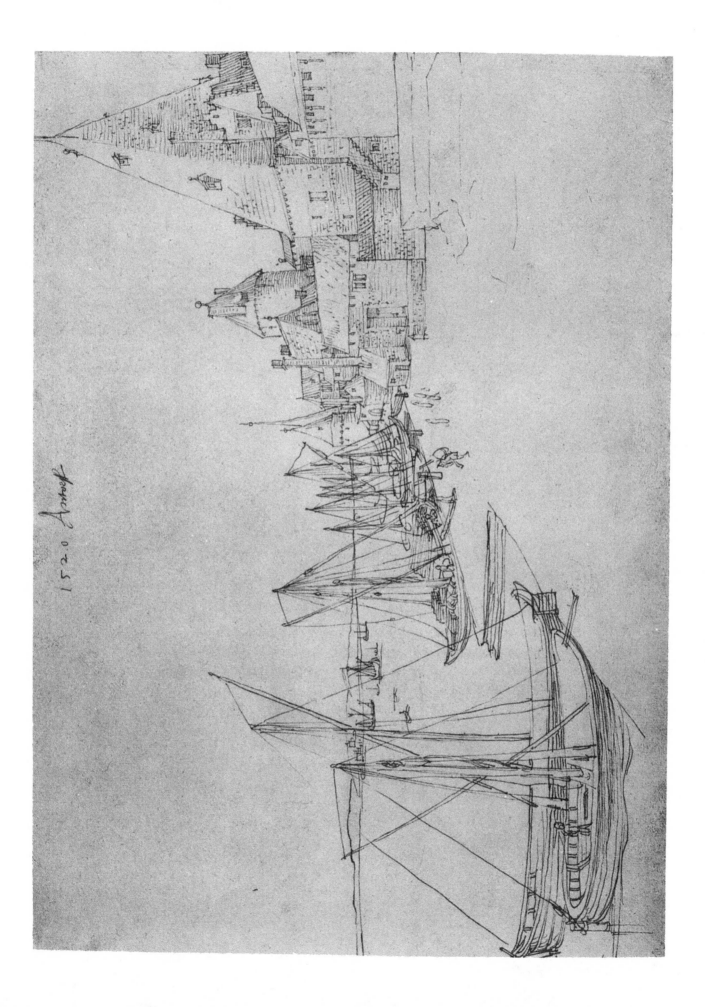

62 PORTRAIT OF AN UNKNOWN MAN. 1520

Chalk. Kupferstichkabinett, Berlin. 365 × 258 mm; 14$\frac{3}{8}$ × 10$\frac{1}{8}$ in.

This is typical of the great late portraits. The line and the representation of form are fully refined, everything momentary in movement and expression being omitted. The subject fills most of the space; there is a dark background with a light band on top.

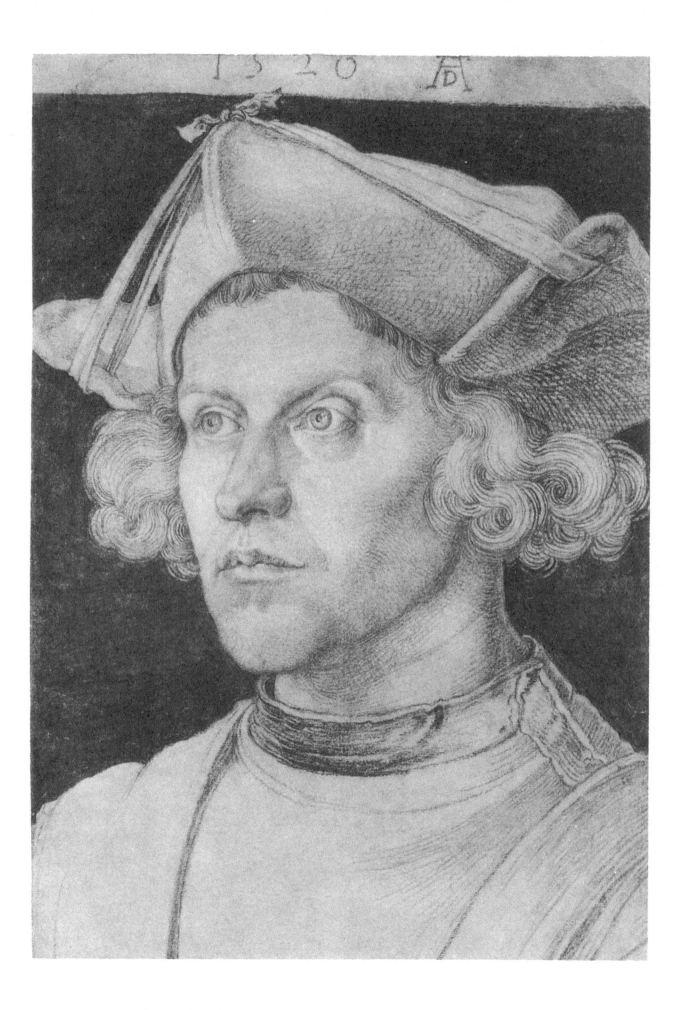

63 "LUCAS VAN LEYDEN." 1521

Chalk and charcoal. British Museum, London. 368 × 255 mm; $14\frac{7}{16}$ × 10 in.

The legend (below left), "effigies Lucae Leidensis," is not by Dürer. The
"L [Lucas] 1525" above it shows that the drawing was once given out to be a
work of the Dutch artist. If that was incorrect, it still cannot be denied that in
its calm physiognomy the drawing is close to the Dutch manner. The hair falling
in strands is not stylized in Dürer's fashion. The whole piece is in the severe
manner of the late period, with a strongly emphasized contrast between the
fundamental horizontal and vertical directions. The background is dark and
uniform.

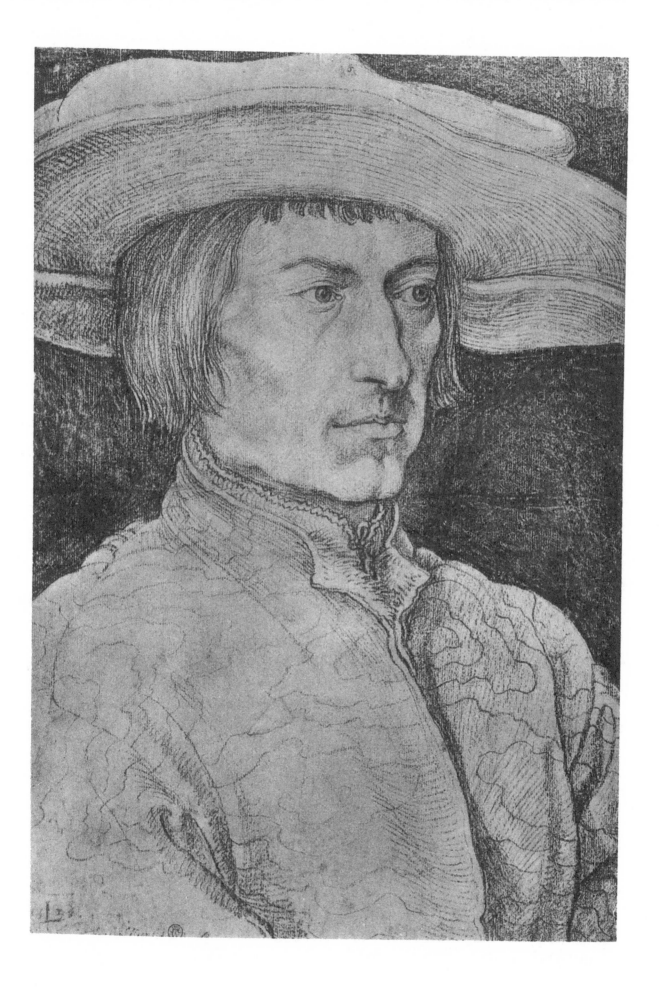

64 PORTRAIT OF ULRICH VARNBÜHLER. 1522

Chalk and charcoal. Albertina, Vienna. 415 × 320 mm; $16\frac{5}{16}$ × $12\frac{9}{16}$ in.

This is a preliminary drawing for the woodcut of the same year, which carries over the line work almost completely—not only the tight wavy parallel lines in the neck, but also the broad downward flow of the line over the shoulders (truly characteristic of a freehand drawing). Only the ear is more cartilaginous in the woodcut, and the background is composed of pure horizontal lines.

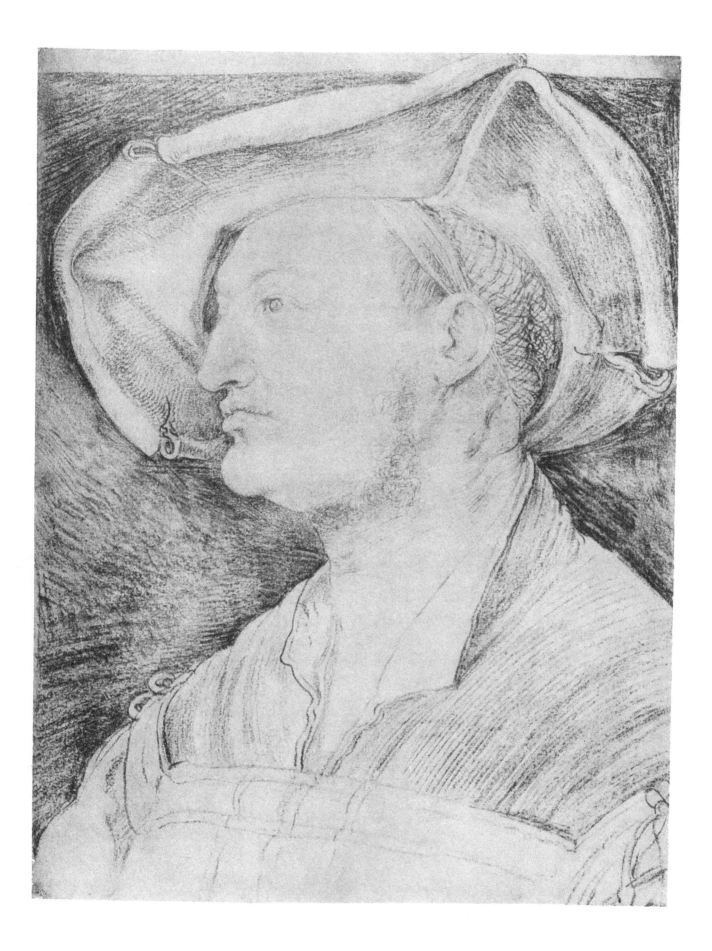

65 HEAD OF AN OLD MAN. 1521

Brush drawing with white highlights on dark paper. Albertina, Vienna.
420 × 282 mm; 16½ × 11⅛ in.

The legend reads: " der Man was alt 93 Jor vnd noch gesunt vnd fermuglich zv antorff " (this man was 93 years old and still healthy and well-to-do in Antwerp). This is a primary example of the combination in the late style of delicate detail with broad concentration. This was drawn with a definite use in a painting already in mind, the " St. Jerome with a Skull " in Lisbon.

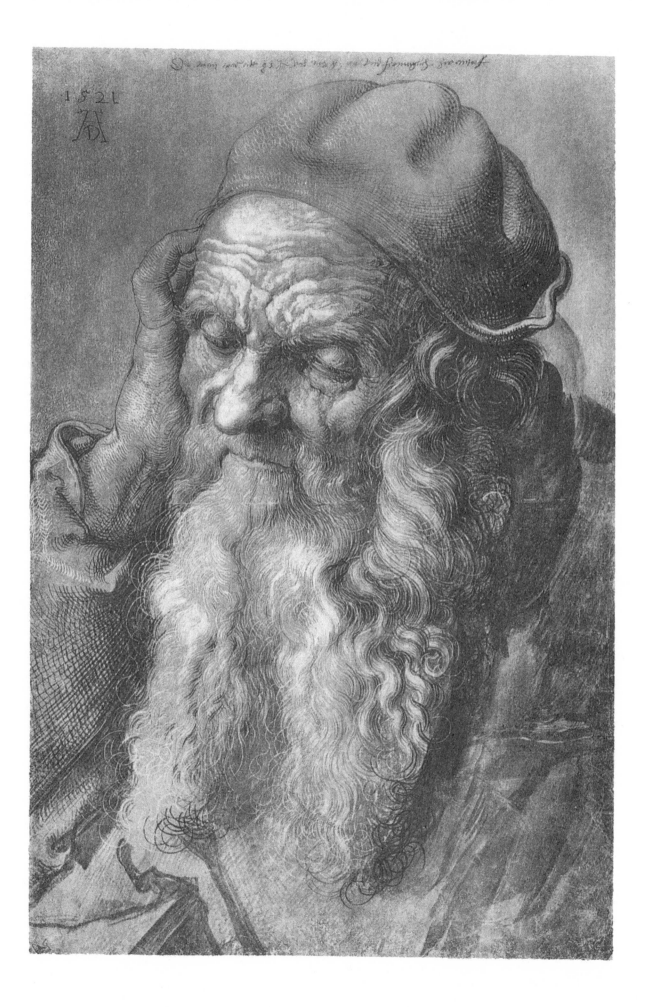

66 STUDY OF DRAPERY. 1521

Brush drawing with white highlights on a dark ground. Albertina, Vienna.
280 × 210 mm; 11 × 8¼ in.

This is typical of the procedure in Dürer's studio. The cloth is placed on a hanger and gathered up in the middle. In comparison with the drapery studies for the "Heller Altar," the broader style and the greater calm in lines and planes are clearly evident. The lines of light are woven into networks, masses of light and darkness are interconnected (above right, below left).

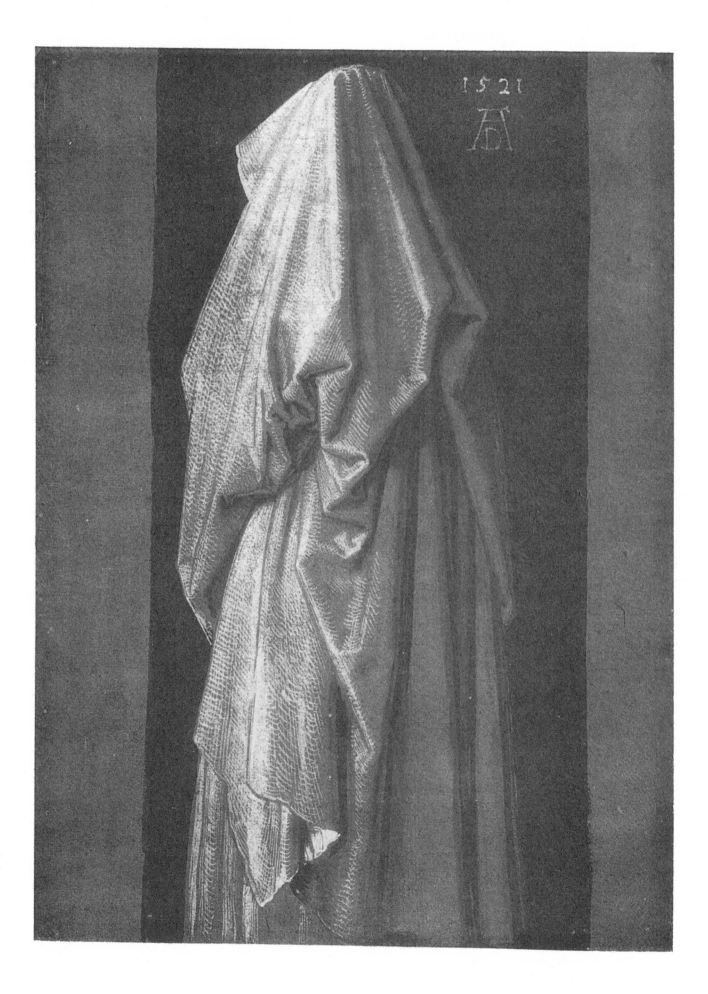

67 WEEPING CHERUB. 1521

Chalk on dark paper. Blasius collection, Braunschweig. 208 × 166 mm; $8\frac{3}{16} \times 6\frac{9}{16}$ in.

This drawing is a study for a Passion painting that was not executed. It forms a contrast to the heads of the cherubim done in Venice (not illustrated here): those were schematic, this is an individual model.

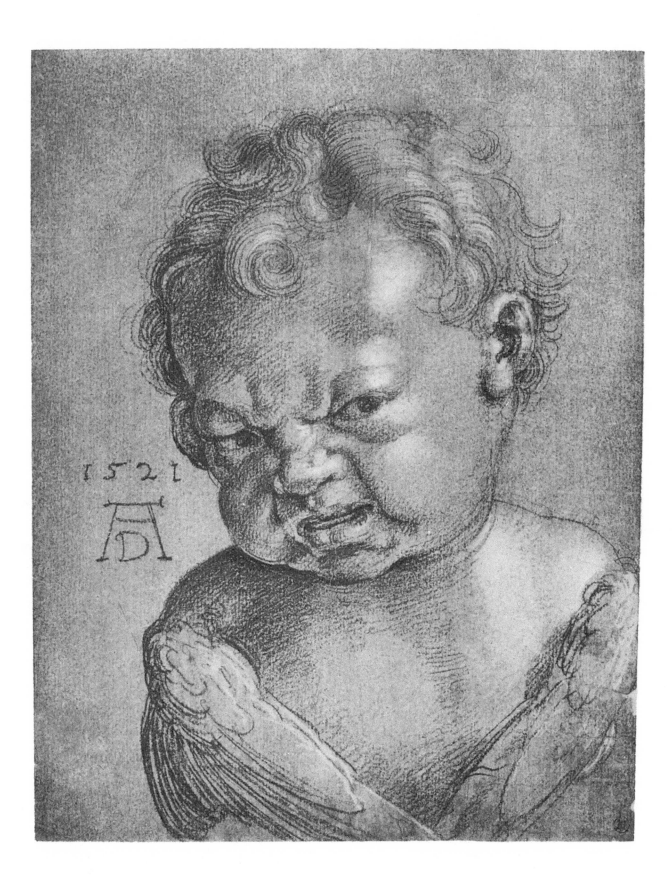

68 THE MAN OF SORROWS. 1522

Metal point on dark paper. Kunsthalle, Bremen. 408 × 290 mm; $16\frac{1}{6}$ × $11\frac{3}{8}$ in.

This is a study for a painting. The painting is lost, and only a mezzotint after it by C. Dooms is known. The very thorough drawing is extremely characteristic of the delicate naturalism of Dürer's last years.

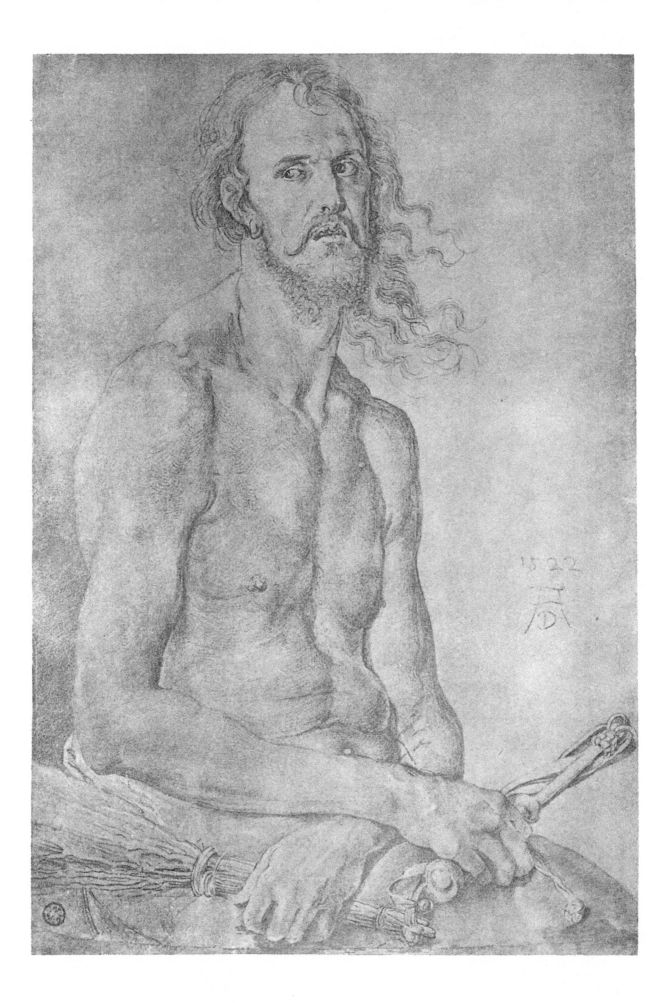

69 St. John lamenting. 1523

Metal point and chalk on dark paper. Albertina, Vienna. 419 × 300 mm; 16½ × 11¹³⁄₁₆ in.

The figure is a study for a large Crucifixion painting that was not executed. In its majestic rhythm it is already very close to the Munich paintings of "Apostles."

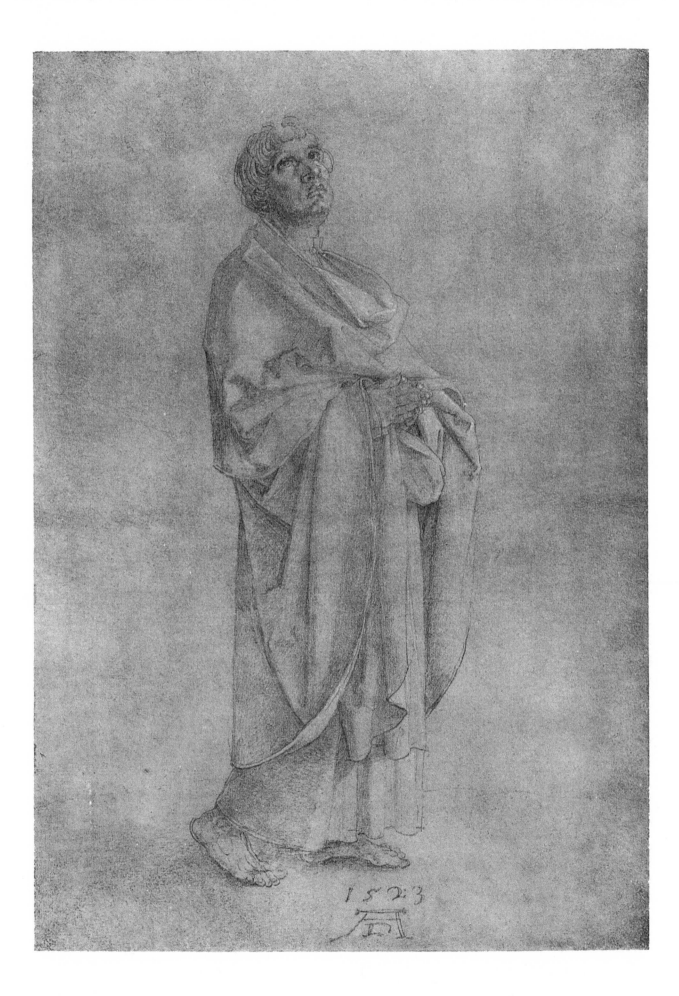

70 The Lamentation. 1522

Silverpoint. Kunsthalle, Bremen. 293 × 416 mm; $11\frac{9}{16}$ × $16\frac{3}{8}$ in.

The corpse is leaning against the knee of the Magdalen, who is seated on the ground (it is not leaning "against an elevation covered by a cloth," as Lippmann says). The Virgin is raising Christ's head and holding his left arm on her lap. St. John and Joseph of Arimathea are visible in half length. This is an extremely significant sketch for a painting in the late style, in which form is entirely saturated with expression. A comparison with Plate 37 will make this clear. How far the corpse in the present drawing surpasses the other as an expression of Christ's sorrow, in the attitude of the head and the limbs that seem to be still alive!

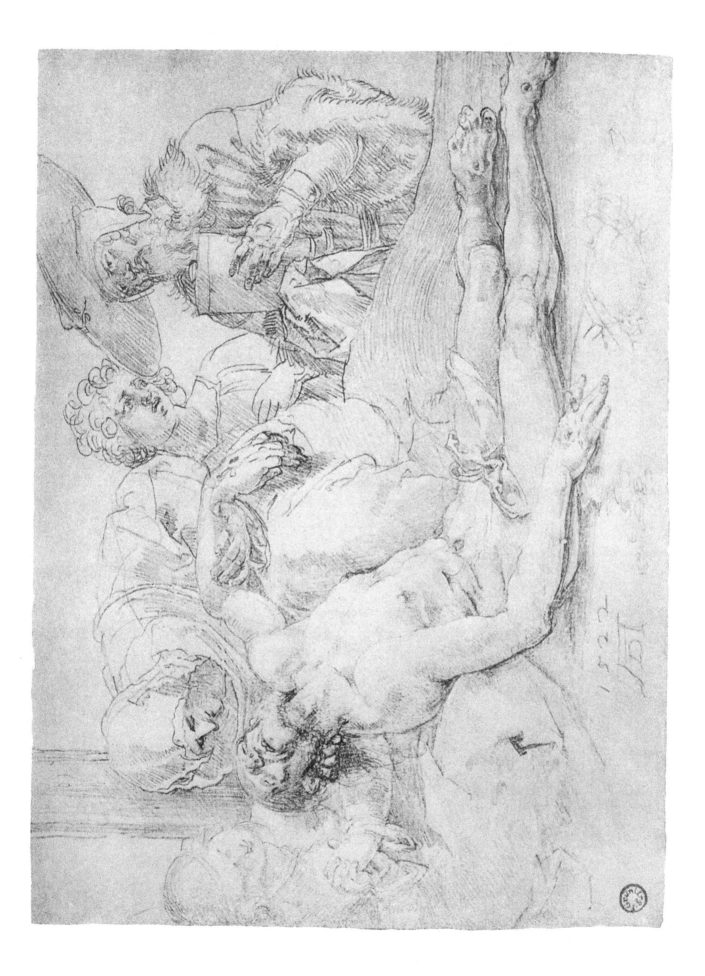

71 THE VIRGIN WITH TWO ANGELS AND FOUR SAINTS (ST. CATHERINE, ST. JOHN THE EVANGELIST, ST. JAMES THE GREAT AND ST. JOSEPH). 1521

Pen. Musée Condé, Chantilly. 252 × 387 mm; $9\frac{15}{16}$ × $15\frac{1}{4}$ in.

This drawing, which is cut at the top, is to be considered as a study for a large painting. It is an example of the new freedom of arrangement on an architectural basis.

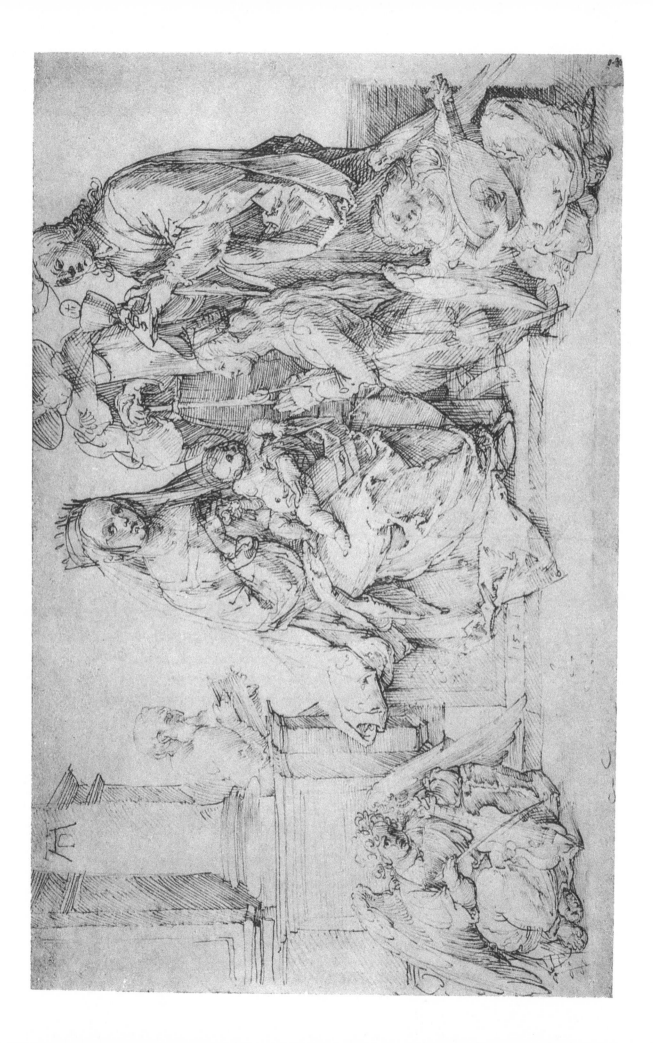

72 THE LAMENTATION. 1521

Pen. Fogg Art Museum, Cambridge. 290 × 210 mm; $11\frac{7}{16}$ × $8\frac{1}{4}$ in.

The drawing is in woodcut style, but with a conspicuously strong feeling for tone in its broad areas of shading. The influence of Dutch art may well be present. Although this drawing does not use the same linear language, it still possesses something of the painterly character of the woodcuts of Lucas van Leyden.

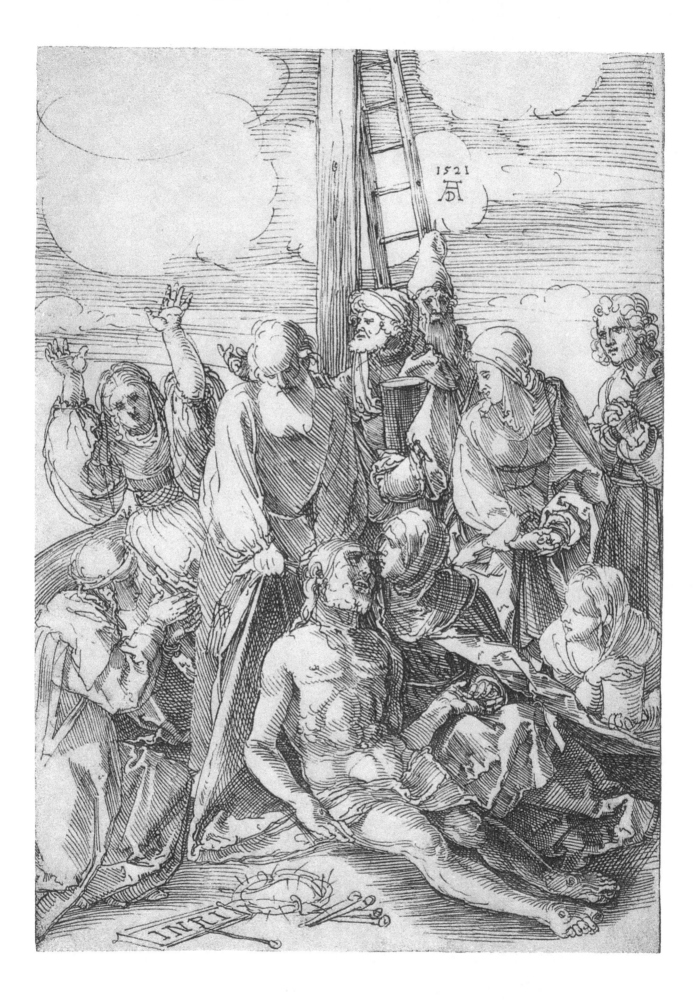

73 CHRIST ON THE MOUNT OF OLIVES. 1521

Pen. Städelsches Kunstinstitut, Frankfurt. 208 × 294 mm; $8\frac{3}{16} \times 11\frac{9}{16}$ in.

Christ is lying completely flat on the ground ("fell on his face, and prayed");
Dürer could have seen this posture depicted by Mantegna. The rocks in stairlike
layers and the veil of mist pressing down from above lend support to the effect of
the motif. The Apostles are small and are sitting off to a side by themselves.

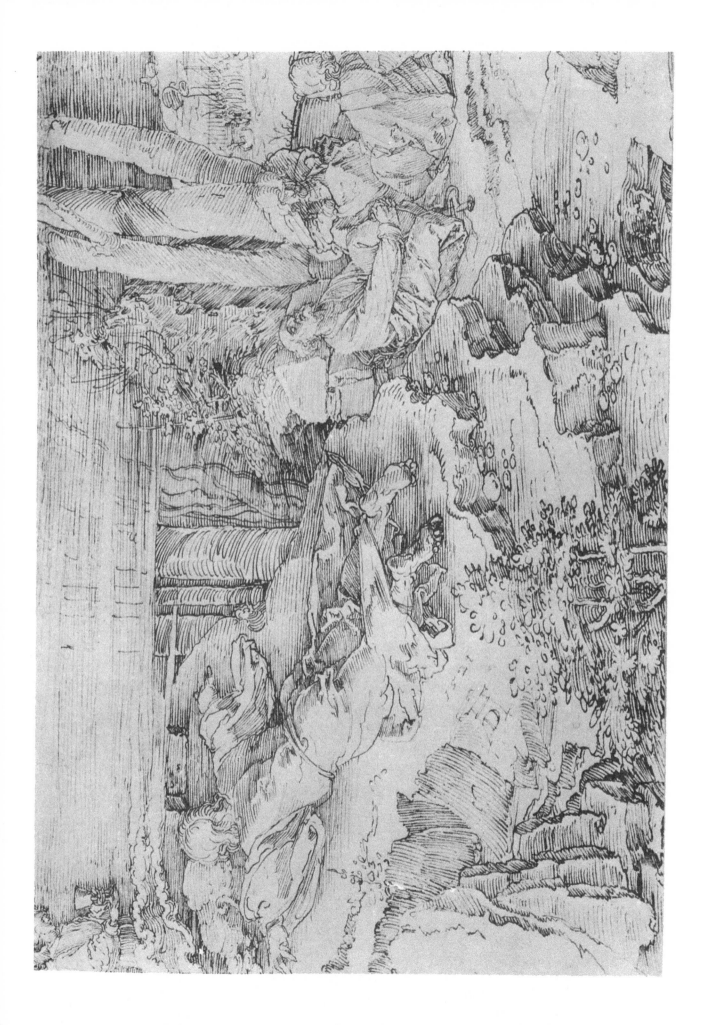

74 CHRIST ON THE MOUNT OF OLIVES. 1524

Pen. Städelsches Kunstinstitut, Frankfurt. 212 × 292 mm; $8\frac{5}{16}$ × $11\frac{1}{2}$ in.

Christ is facing the angel with arms thrust upward. The curve of the sleeping Apostles leads toward him in a broad sweep. Despite the size of the Apostles and the specific characterization of each of them in his position, they remain subordinate to the principal figure. In the center foreground the stage is completely empty. This drawing is the final version of a theme that interested Dürer at almost all times. It is a study for the late Passion woodcut series of which only " The Last Supper" was transferred to the wood block.

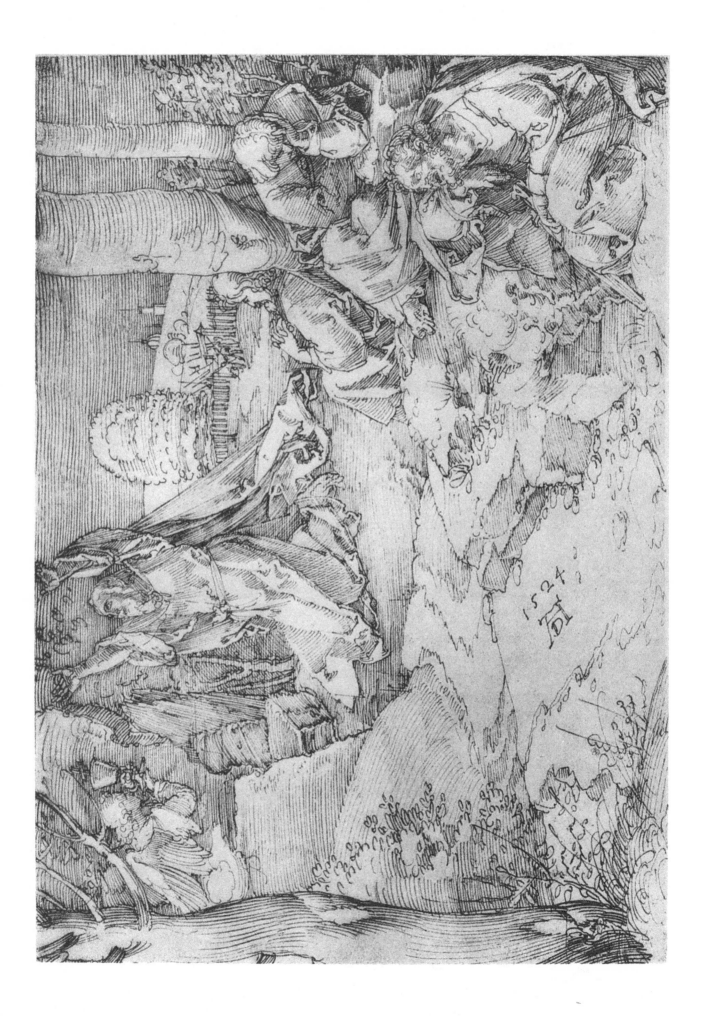

75 THE ADORATION OF THE WISE MEN. 1524
Pen. Albertina, Vienna. 215 × 294 mm; $8\frac{7}{16}$ × $11\frac{9}{16}$ in.

Perhaps this is a study for the introductory piece of the last, uncompleted,
Passion woodcut series. The nobility of the composition is combined with a truly
radiant beauty of line.

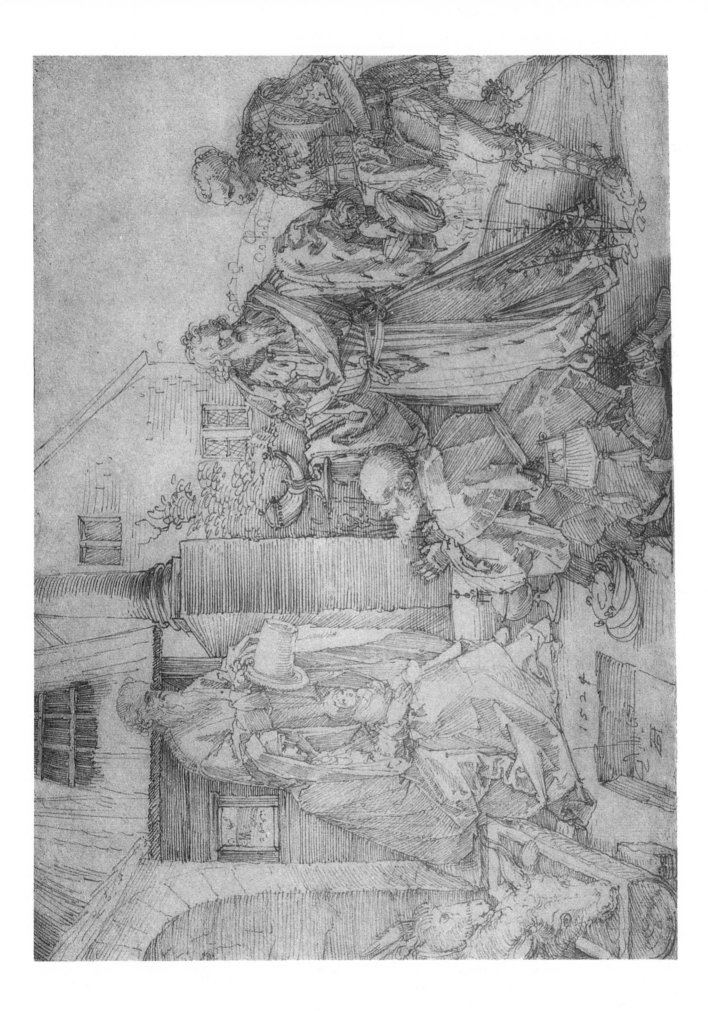

76 MASS. 1523

Pen. Kupferstichkabinett, Berlin. 307 × 221 mm; $12\frac{1}{16}$ × $8\frac{3}{4}$ in.

The late date is justified by the simplified and strictly planar representation. Depth of field is not lacking, but occurs only in a regular succession of planes. The drawing also has interest for historians of architecture: an arcade with columns that have an intermediate entablature above their capitals. The connection between this and the transverse column pairs in the side aisle (which breaks down into isolated bays) is unclear. The geminate altarpiece is in pure (North Italian) Renaissance style.

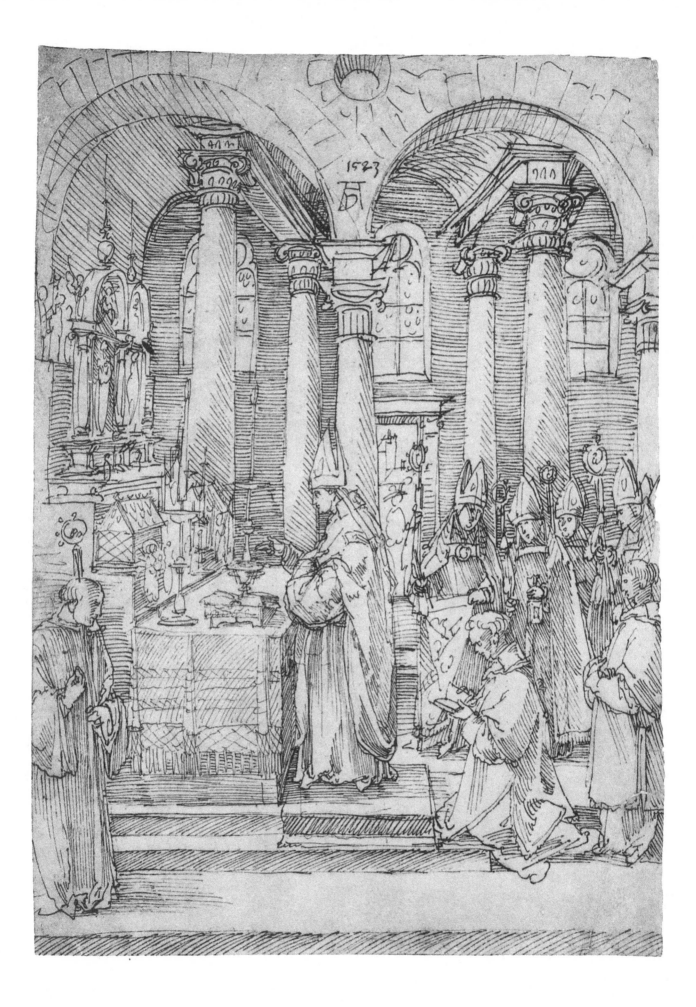

77 FIVE MALE NUDES. 1526
Pen. Kupferstichkabinett, Berlin. 185 × 195 mm; $7\frac{5}{16}$ × $7\frac{11}{16}$ in.

This drawing, in woodcut style, may have been a study for a Resurrection.

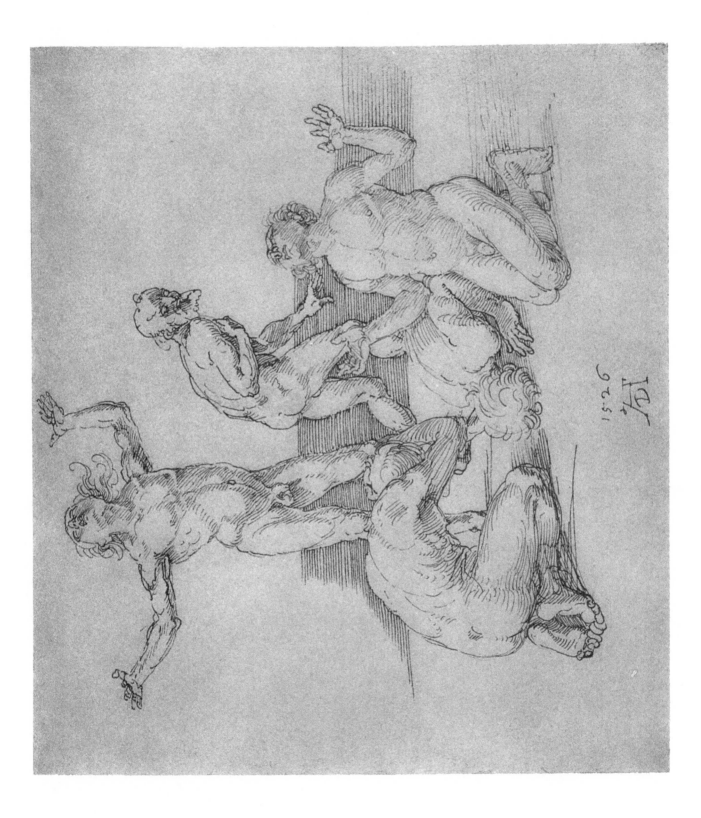

THE PIECE OF TURF WITH THE COLUMBINE.

Opaque colors. Albertina, Vienna. 363 × 292 mm; $14\frac{5}{16}$ × $11\frac{1}{2}$ in.

The date 1526 is not authentic. Nevertheless the drawing cannot be set alongside the 1503 "Piece of Turf." Here the inexhaustible has become simple, reduced in quantity, graspable. Perception has been made considerably easier for the eye. This is not the spectacle of an accidental phenomenon, but the typical form of the subject. The simplification of the color parallels that of the draftsmanship.

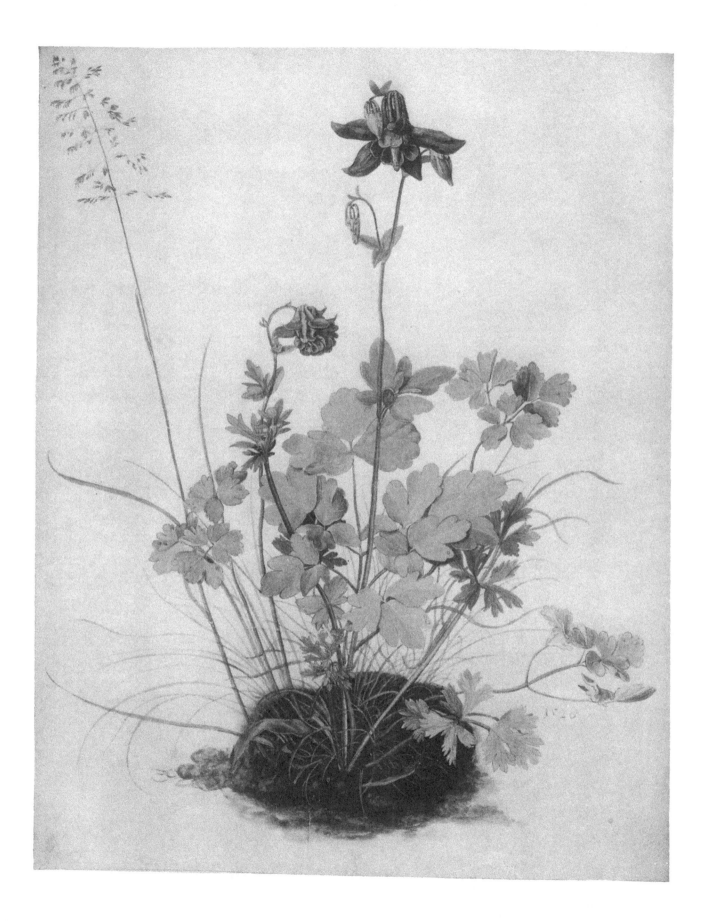

79 HEAD OF ST. MARK. 1526

Chalk with white highlights. Kupferstichkabinett, Berlin. 373 × 265 mm; $14\frac{11}{16} \times 10\frac{7}{16}$ in.

This is a study for the Apostle in the great Munich painting. In its expression of spiritual excitement the head in this drawing is decidedly superior to the one in the painting. Tossing briskly, the locks of hair continue the theme of movement. At the same time, the natural appearance of the hair seems to have been oddly neglected in the rendering ("pretzel locks"). Drawings of this type, in very large format and only superficially finished, do not occur in the earlier period.

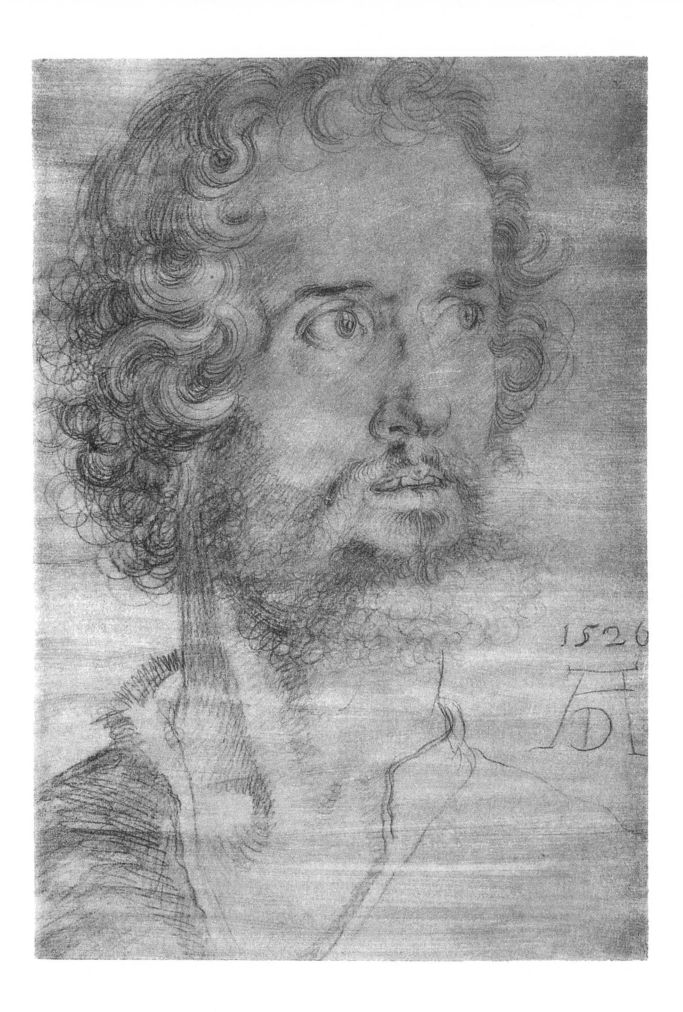